ANiMATiNG

THE LOONEY TUNES™ WAY

WiTH *Tony Cervone*

DiRECTOR,
WARNER BROS. ANiMATiON

Walter Foster™

WORLDWIDE PUBLISHING™

CONTENTS

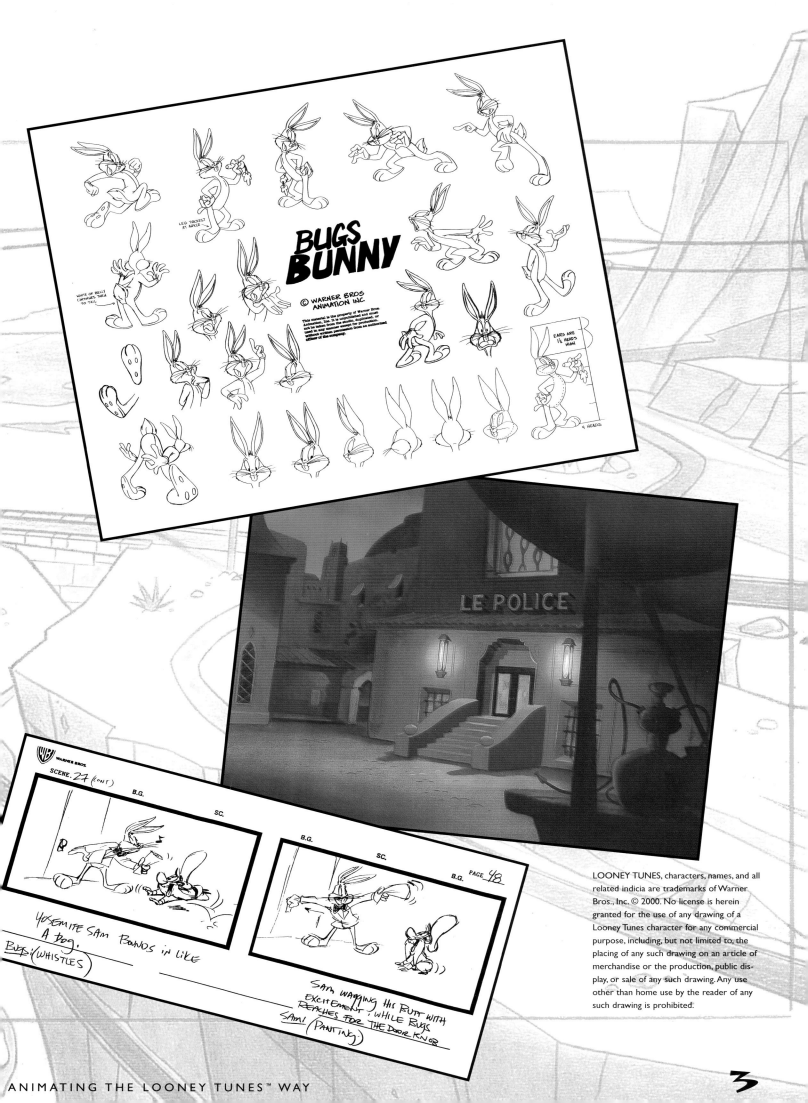

635 Words About Animation

Why do mere scratches of pencil on paper make us laugh so hard? What makes Bugs Bunny a sly and cunning hero? What makes Daffy Duck a self-defeating egomaniac or Porky Pig a stuttering "Everyman"? What sets Looney Tunes characters apart from their cartoon brethren? Answer ...

Most cartoons are well drawn, and most have nicely painted backgrounds and competent music. So, why are Looney Tunes cartoons better? It's simple—Warner Bros. cartoons don't hold back. They exaggerate; they invent; they aren't afraid or timid. The characters are pure. The scripts are funnier than other cartoon scripts because they are more daring. The Warner Bros. music and sound effects are more inventive. The timing and cuts are sharper and more precise. The style of the backgrounds is "snappier" and more dynamic than can be found in any other style of cartoon.

Looney Tunes cartoons just have more of everything, and there is a lot to learn about art, music, and comedy from watching a bunch of silly cartoons.

So how do you, budding young cartoonist, fit into this? For starters, become more critical about the cartoons you watch. What do you like about animated cartoons? What makes you laugh? Why do you like one character more than another? What characters are most like you?

You have a lot to learn, but don't be intimidated. Animation is a big subject that many people have devoted long careers to. Please don't let this book overwhelm you, and try not to get frustrated if your drawings don't look the way you want them to when you start out. It takes a year or two to fully understand the principles of animation. It takes another five or six years of practice to get any good at it. It's a good thing many of you are young! You have a lot of time!

You'll find that this book is an introduction to some basic artistic principles. Don't skip ahead to the more exciting stuff. Learn the basics first! Practice simple shapes before you move on. Stop whining and do your homework!

See how animators make cartoon hands both fun and functional.

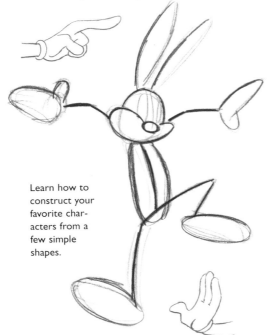

Learn how to construct your favorite characters from a few simple shapes.

Get acquainted with new Looney Tunes characters, or become reacquainted with old friends!

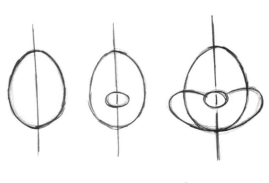

Discover how easy it is to draw a cartoon head—or anyone's head!

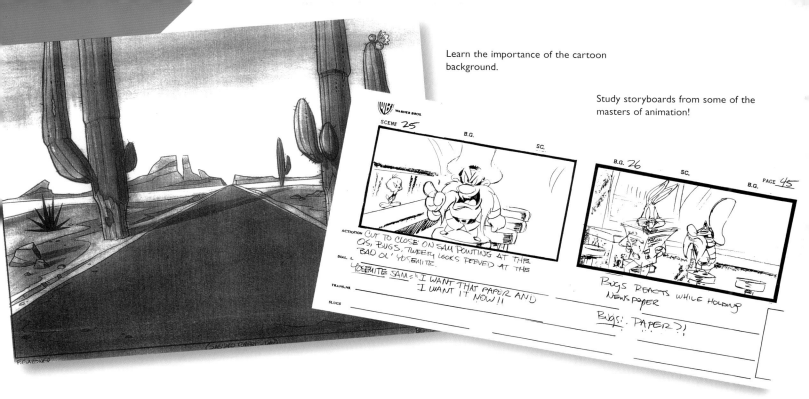

Learn the importance of the cartoon background.

Study storyboards from some of the masters of animation!

Don't freak out if your drawings aren't perfect. Stay loose. Don't copy model sheets too much; they are only for reference. Try making your own model sheets. Think about stories. Why do some work and others don't? Write your own stories. Do something new.

Study the backgrounds in your favorite cartoons. Form your own opinions about what you like and don't like. Draw your own background layouts and color them any way you want. Learn the rules of color harmony, and then break them!

Watch animation closely. Watch it in slow motion. How does an animator turn a simple walk into a cocky swagger? How can a drawing of a simple smirk convey thought and cleverness? I hope this book makes you think of animators as actors—actors who must have a sense of timing that can get a laugh and who portray pure emotions such as anger, fear, joy, and exuberance. Think about animation more than you

ever have before. Dissect it. How does a scene play on more than one level? How can a character's actions portray suave intellect and brute physical force at the same time?

After reading this book, I hope you will listen to cartoon music and sound effects more closely. How does the music reinforce the action and mood of the animation? Why are those sound effects so darn funny?

Above all, you must have fun! This is the true secret ingredient in Looney Tunes style cartoons. They are just more plain fun than other cartoons. There is a fair amount of technical jargon and heady principles in this book, but don't get bogged down. Have fun! Exaggerate! Invent new characters! Write new stories! Change things! Make things better!

Good luck, and keep drawing!
Your pal,

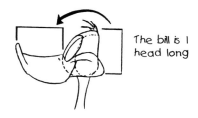

The bill is 1 head long

Find out all the tricks of the cartooning trade, from sizing features to building a whole body in proportion.

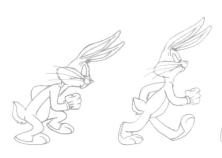

Daffy is about 4 heads high

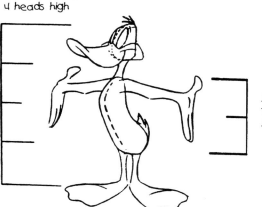

Daffy's torso is 2 heads high

Master the basic animation cycles.

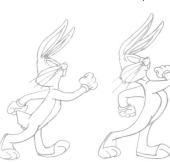

1 CHARACTER DEVELOPMENT

When beginning to draw

funny cartoons, most people want to do the same thing: dive right in and draw in the minutest details! They want to draw every hair and whisker first. Then, when their drawing doesn't come out right, they wonder what went wrong! Sorry, kids, but like most things, if you want to learn to draw funny Looney Tunes style cartoons, you'll need to start at the beginning. That means you start simple and add hilarious detail later. First off, you budding cartoonists need to learn a bunch of "fancy pants" rules and theories about good drawing. If you don't learn the rules now, you won't be able to break them later!

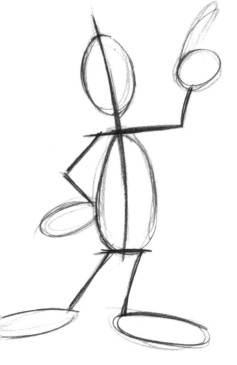

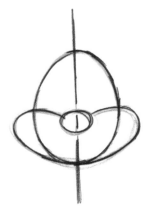

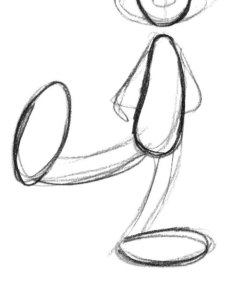

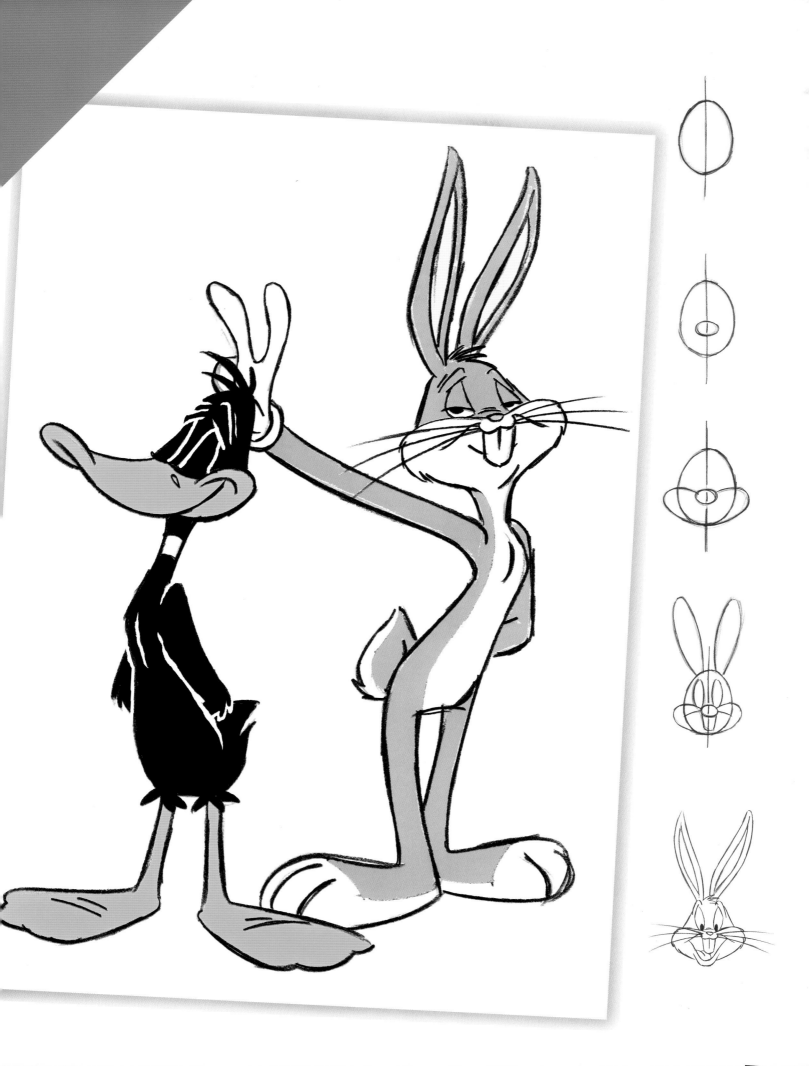

WHO'S WHO

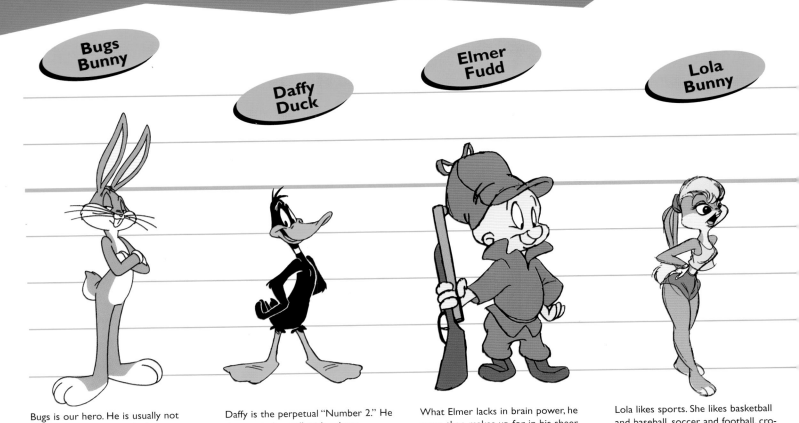

Bugs Bunny

Daffy Duck

Elmer Fudd

Lola Bunny

Bugs is our hero. He is usually not dangerous unless provoked.

Daffy is the perpetual "Number 2." He does not play well with others.

What Elmer lacks in brain power, he more than makes up for in his sheer desire to shoot things.

Lola likes sports. She likes basketball and baseball, soccer and football, croquet, jai-alai, lawn bowling . . . Lola likes sports a lot.

Instant Martian

Evil Scientist

Yosemite Sam

The Instant Martians are big, stupid, and expendable—just like many professional athletes.

Although the Evil Scientist isn't much in the personality department, he is an excellent karaoke singer.

Yosemite Sam is a mean little cowboy. Say no more.

As if they needed an introduction at all—ladies and gentlemen, boys and girls . . . the Looney Tunes! A lineup like this helps us gauge the sizes of the characters in relation to one another. It also just looks nice to see them all in one place—kind of like their class picture. So give it a quick perusal, and then let's get down to business . . .

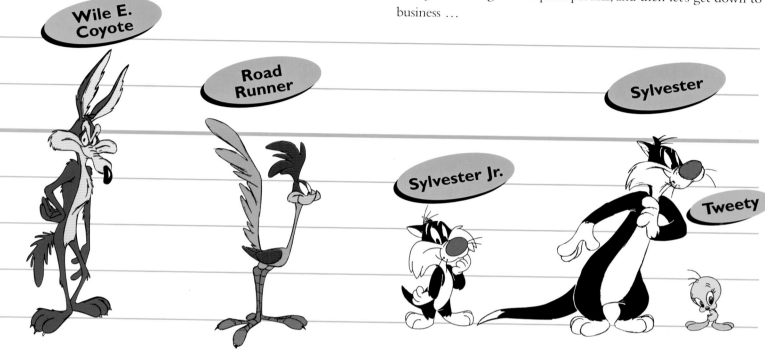

Wile E. is good at being an obsessed, super genius. He just isn't good at anything else.

Road Runner is an enigma. We don't know much about his likes or dislikes. We just know that he is really good at avoiding obsessed, super-genius coyotes.

Cute little scamp, isn't he?

Sylvester's life would improve dramatically if he became a vegetarian. He will never learn.

Tweety likes nothing more than singing on his perch. In fact, he seems unaware of Sylvester's hungry desires. In truth, Tweety hides one of the most diabolical minds known to man.

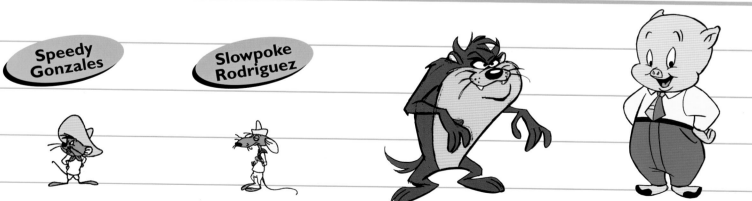

Everything about Speedy is fast. He's light on his feet, quick-witted, and can cook a 3-minute egg in 2 minutes.

Slowpoke is so slow that when he left for school on the first day of kindergarten, he arrived in time for his 8th-grade graduation

The Tasmanian Devil has eaten most things that walk, crawl, fly, or swim across the planet, but he still doesn't like Brussels sprouts.

Porky Pig is a porcine "Everyman." Let's give a big Looney Tunes salute to Porky!

WHO'S WHO, CONTINUED

Pepe Le Pew

Penelope

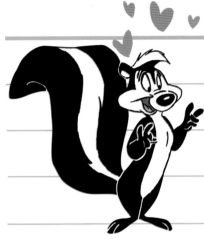

Michigan J. Frog

Pepe Le Pew and Penelope are classic star-crossed lovers. Remember, kids: Love isn't a destination; it's a journey.

Penelope is the feline object of Pepe's desires. In every cartoon, she accidentally manages to paint a stripe down her back and look like a skunk. What are the chances of that? It happens in EVERY cartoon! It defies logic, I tell ya!

Michigan J. Frog has gone from being the star of a single cartoon to being the host of an entire network! Not bad for a guy who eats flies.

K-9

Marvin The Martian

Foghorn Leghorn

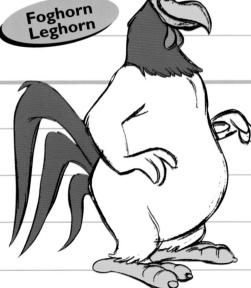

Henery Hawk

K-9 has sworn to serve and protect his master, Marvin The Martian. At least he gets a decent dental plan in return.

Marvin The Martian isn't a bad guy; he just wants to destroy Earth to get a better view of Venus. It's understandable, if you think about it.

Foghorn Leghorn is a big, fat guy who enjoys nothing more than lying around, eating, and torturing his friends. He's a rooster after my own heart.

Henery Hawk has something to prove. He must prove that he can catch a chicken. That's all there is to say about Henery Hawk.

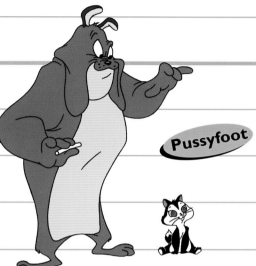

Marc Antony is a bulldog who has his own kitten, Pussyfoot. Who says that 21st-century males don't have a sensitive side?

Pussyfoot is the adorable kitten adopted by Marc Antony. Why, the little critter's so sweet, my fillings hurt just looking at her.

Hassan likes to chop. Chop, Hassan, chop.

The Crusher is a boxer and wrestler, but many don't know that he is also a licensed specialist in *feng shui*.

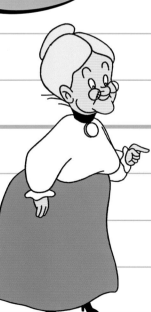

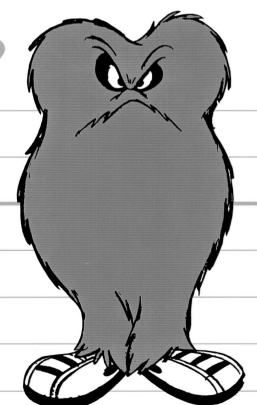

Granny is so old that her dentures are made from petrified wood.

Gossamer may look ferocious, but underneath all that fur he's just cute and lovable—and naked!

Basic Forms

OK, folks. This is as simple as it gets—easy, ball-type, circular cartoon construction. Do you think this is boring yet? Well, keep your pants on and your ears open! Ya see, circular forms are nice and simple to draw—and when you're animating, you have to draw a lot! So study the simple forms and think about what happens to things when you rotate them in three-dimensional form and look at them from different angles. Notice that the forms aren't simple circles, anymore—they're oval and pear-shaped and that kind of stuff! Real circles are for mechanical engineering and geometry and junk like that—not for drawing cartoons!

Bugs Bunny's Basic Form

Visualize simple shapes—work out your proportions in the simplest way possible, and then add the details!

Lola's Basic Form

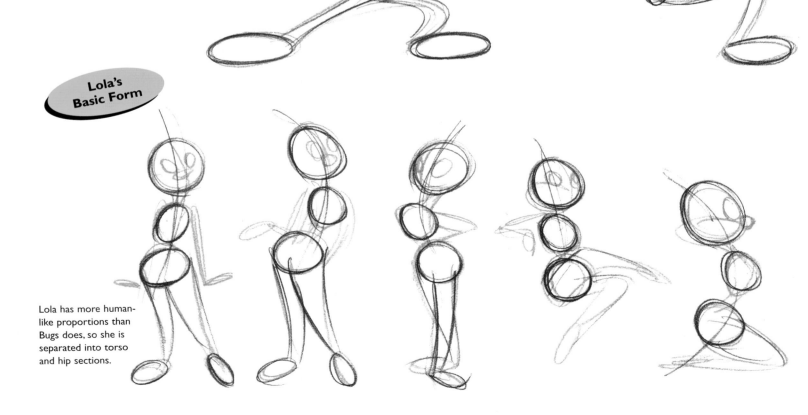

Lola has more human-like proportions than Bugs does, so she is separated into torso and hip sections.

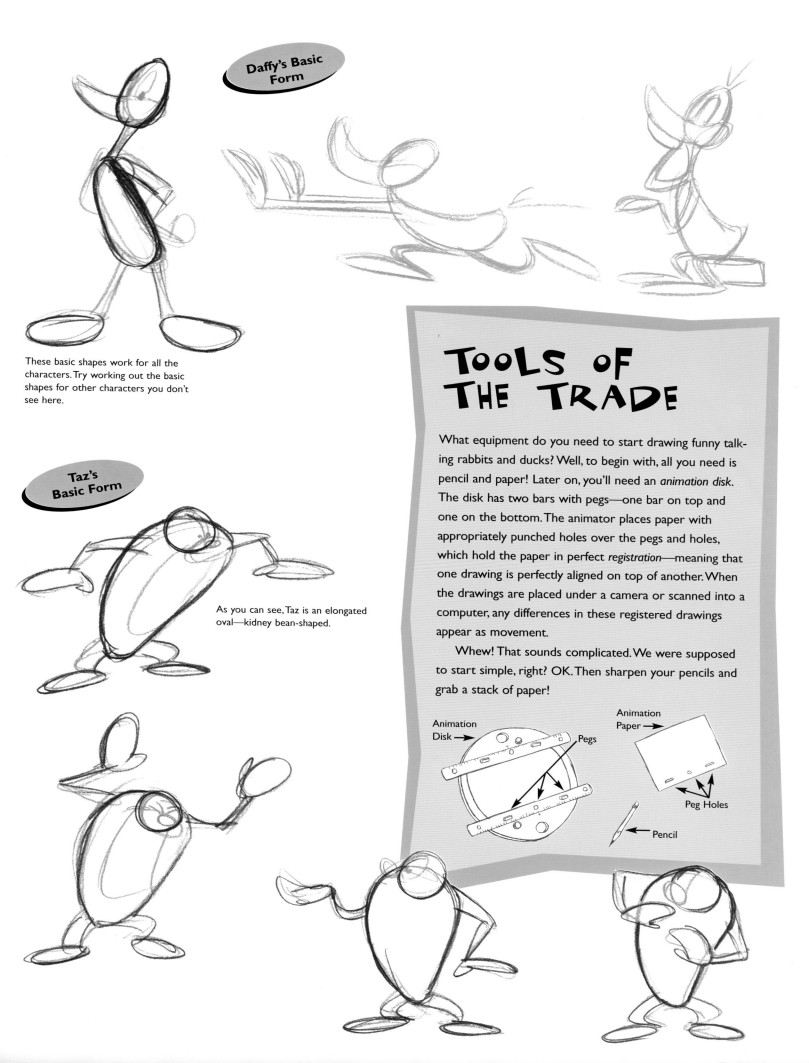

Daffy's Basic Form

These basic shapes work for all the characters. Try working out the basic shapes for other characters you don't see here.

Taz's Basic Form

As you can see, Taz is an elongated oval—kidney bean-shaped.

TOOLS OF THE TRADE

What equipment do you need to start drawing funny talking rabbits and ducks? Well, to begin with, all you need is pencil and paper! Later on, you'll need an *animation disk*. The disk has two bars with pegs—one bar on top and one on the bottom. The animator places paper with appropriately punched holes over the pegs and holes, which hold the paper in perfect *registration*—meaning that one drawing is perfectly aligned on top of another. When the drawings are placed under a camera or scanned into a computer, any differences in these registered drawings appear as movement.

Whew! That sounds complicated. We were supposed to start simple, right? OK. Then sharpen your pencils and grab a stack of paper!

Animation Disk →

Pegs

Animation Paper →

Peg Holes

Pencil

ADDING A SKELETON

OK. Now that you're a master at circular construction, let's add some bones! That's right—you don't want your characters to fall apart into a bucket of glop, do ya? First try drawing a skeleton. Just make a couple of lines for a spine, arms, and legs—simple-like. Then add some circular body shapes over it. This will help give your drawings a solid feel and keep them in proportion. Easy, huh? Yeah, right! Keep drawing!

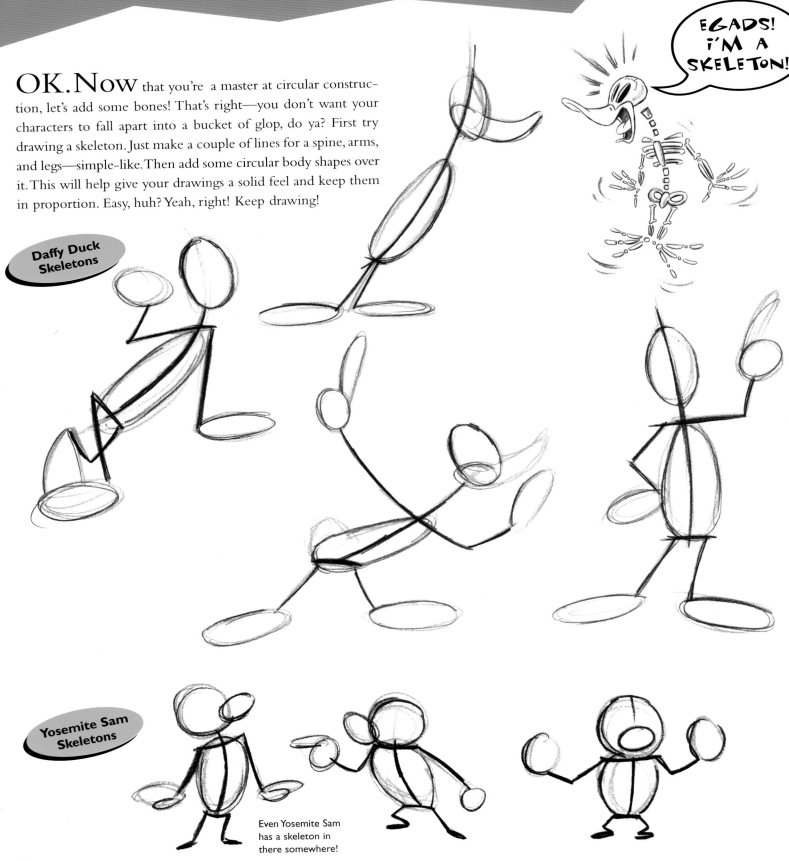

EGADS! I'M A SKELETON!

Daffy Duck Skeletons

Yosemite Sam Skeletons

Even Yosemite Sam has a skeleton in there somewhere!

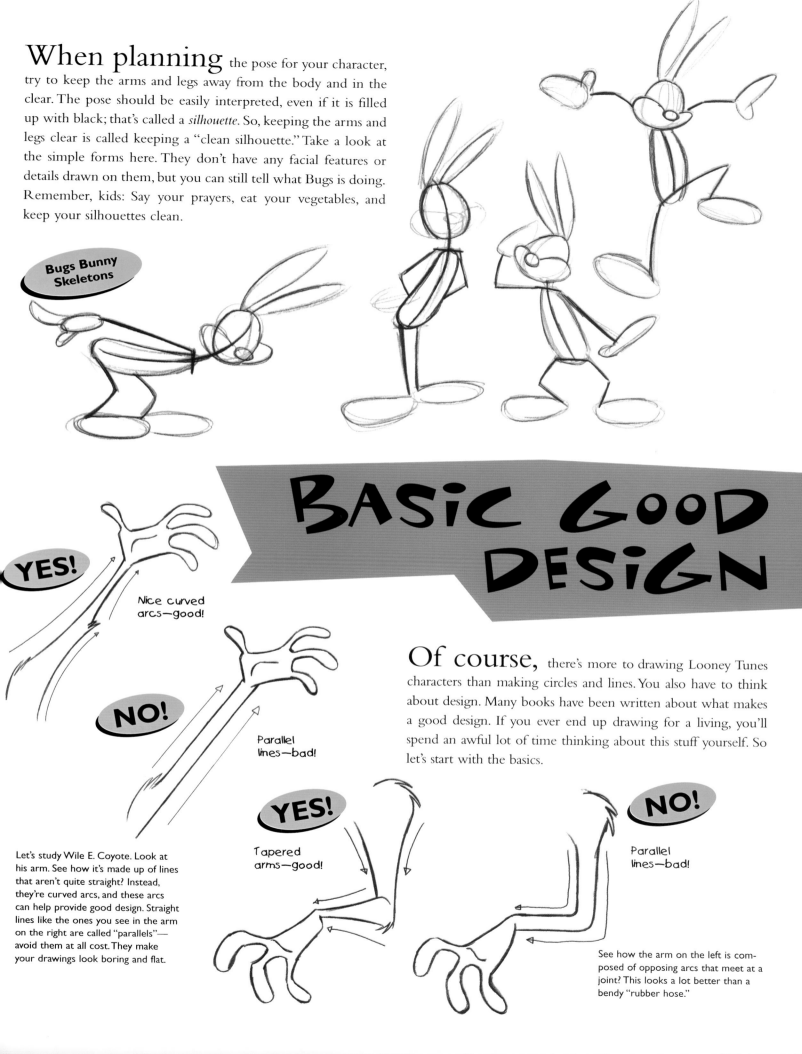

When planning the pose for your character, try to keep the arms and legs away from the body and in the clear. The pose should be easily interpreted, even if it is filled up with black; that's called a *silhouette*. So, keeping the arms and legs clear is called keeping a "clean silhouette." Take a look at the simple forms here. They don't have any facial features or details drawn on them, but you can still tell what Bugs is doing. Remember, kids: Say your prayers, eat your vegetables, and keep your silhouettes clean.

Bugs Bunny Skeletons

BASIC GOOD DESIGN

YES!

Nice curved arcs—good!

NO!

Parallel lines—bad!

Of course, there's more to drawing Looney Tunes characters than making circles and lines. You also have to think about design. Many books have been written about what makes a good design. If you ever end up drawing for a living, you'll spend an awful lot of time thinking about this stuff yourself. So let's start with the basics.

Let's study Wile E. Coyote. Look at his arm. See how it's made up of lines that aren't quite straight? Instead, they're curved arcs, and these arcs can help provide good design. Straight lines like the ones you see in the arm on the right are called "parallels"— avoid them at all cost. They make your drawings look boring and flat.

YES!

Tapered arms—good!

NO!

Parallel lines—bad!

See how the arm on the left is composed of opposing arcs that meet at a joint? This looks a lot better than a bendy "rubber hose."

BASIC HEAD CONSTRUCTION

Back to the ball! Ya gotta keep your eye on it! (Get it?) Think of the head as a simple ball, and think about what happens to the shapes of the eyes, nose, and other facial features when the ball rotates. Imagine it in your head. When you animate, you have to think in three dimensions. It's not as easy as it looks, but keep practicing, and you'll soon get the hang of it.

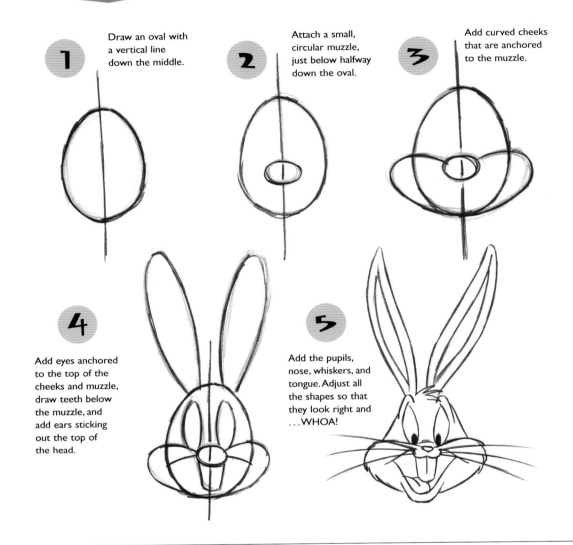

1 Draw an oval with a vertical line down the middle.

2 Attach a small, circular muzzle, just below halfway down the oval.

3 Add curved cheeks that are anchored to the muzzle.

4 Add eyes anchored to the top of the cheeks and muzzle, draw teeth below the muzzle, and add ears sticking out the top of the head.

5 Add the pupils, nose, whiskers, and tongue. Adjust all the shapes so that they look right and ...WHOA!

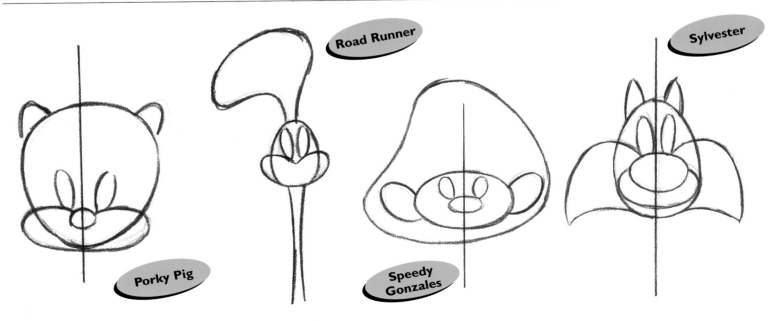

Porky Pig

Road Runner

Speedy Gonzales

Sylvester

HEAD TILT AND PERSPECTIVE

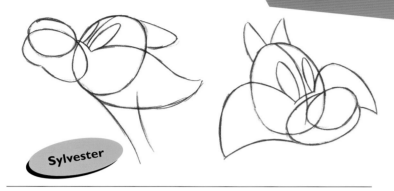

Sylvester

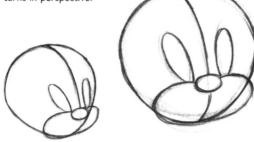

Note the changes in the basic shapes as the head turns in perspective.

Tweety

Have you ever noticed that all the Looney Tunes characters have big cheeks that attach to a muzzle and anchor their eyes onto their heads? Well, I bet you didn't. (OK, maybe some of you did.) At any rate, the characters do have these cheek–muzzle–eye arrangements, and they have them for a reason. It takes a whole boatload of artists to create an animated cartoon, and if you keep things simple, you have fewer chances to mess things up down the road! So look closely at these figures, and see what happens when you tilt the head up and down or rotate it.

Remember to draw eyes in perspective. *Perspective* means, generally, that things closer to you look bigger, and things farther away look smaller. Study the formula, and then try drawing these heads in different positions.

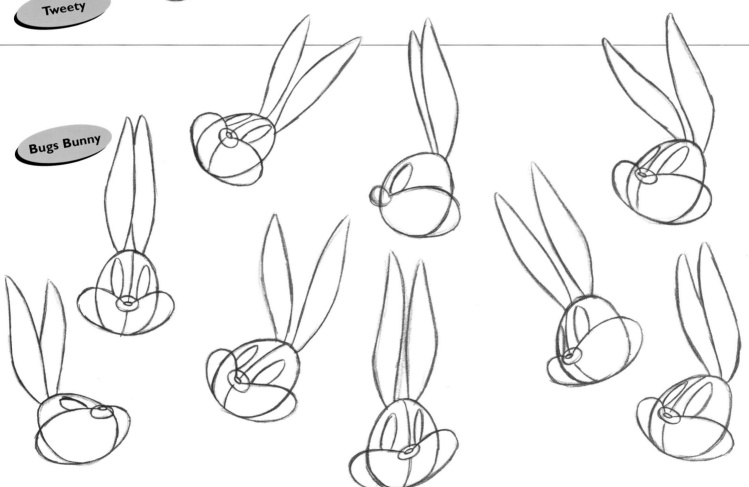

Bugs Bunny

BASIC HANDS

Hands aren't very easy to draw, are they? Well, start simple! Study these basic forms. Don't place all the fingers evenly in a row—that looks kinda weird! Think of the hand as it changes in perspective. Also keep in mind that *overlapping,* or putting one thing in front of another, is a basic element of good design.

Now put in the fingers, varying their positions so the hand doesn't look flat!

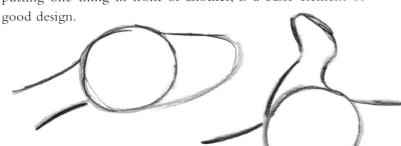

1 Start by outlining the basic shape of the hand, without trying to distinguish the different fingers from one another.

2 Now draw this basic hand shape with a thumb attached, as if you're drawing a mitten.

4 Maybe tilt the fingers a little, here and there—find something you like, and stick to it.

Here are some different hand positions. Notice that cartoon characters usually have only three fingers and a thumb.

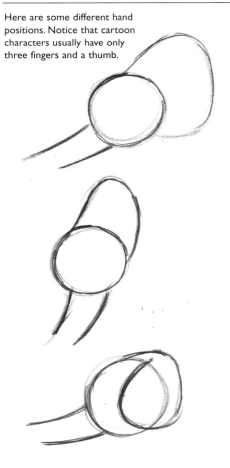

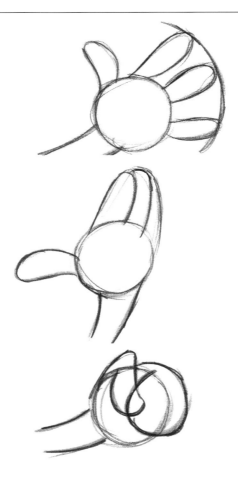

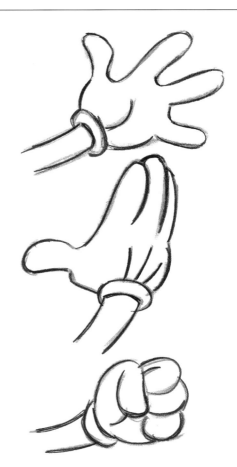

ADVANCED HANDS

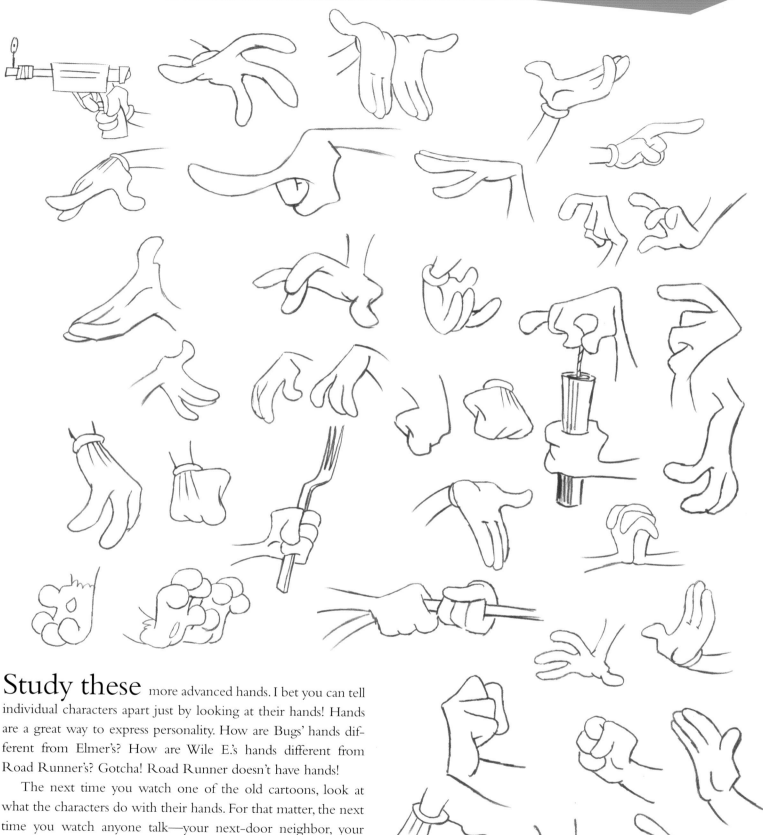

Study these more advanced hands. I bet you can tell individual characters apart just by looking at their hands! Hands are a great way to express personality. How are Bugs' hands different from Elmer's? How are Wile E.'s hands different from Road Runner's? Gotcha! Road Runner doesn't have hands!

The next time you watch one of the old cartoons, look at what the characters do with their hands. For that matter, the next time you watch anyone talk—your next-door neighbor, your grandma, a traffic cop, the mail carrier, anyone—study what they do with their hands. Remember that animators observe everything around them and use these observations in their animation. Don't be put off by the fact that your mail carrier probably has five digits on each hand instead of four!

LiNE OF ACTiON

"**What does** *line of action* mean?" you ask? Well, pretend you see a line traveling through your cartoon drawing, indicating its main thrust of movement. That's the line of action. Preston Blair, in his pioneering Walter Foster book *Cartoon Animation,* described the line of action many years ago as "an imaginary line extending through the main action of the figure." Anyway, you should plan your drawing around this line to achieve the maximum possible dramatic effect. This is one of the things that separates a sorta funny or OK drawing from a really strong, knee-slapping, belly laugh of a drawing.

Study these figures—identify the line of action. Copy them, looking for the line of action in the different drawings and in everything around you. Remember that this will really help your animation appear lifelike.

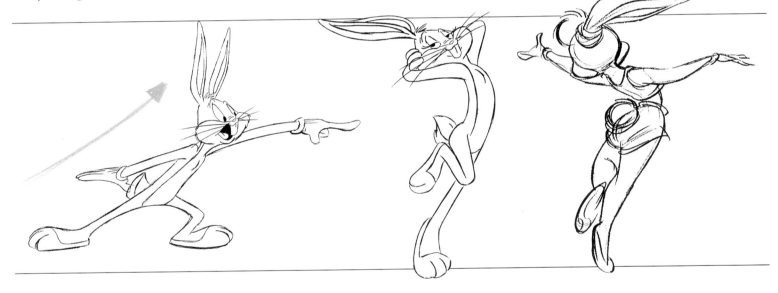

Now we have good, clear lines of action. See how the arcs travel gracefully through the characters? This is a fine example of clear staging. Boy, is Barnyard Dog gonna get walloped!

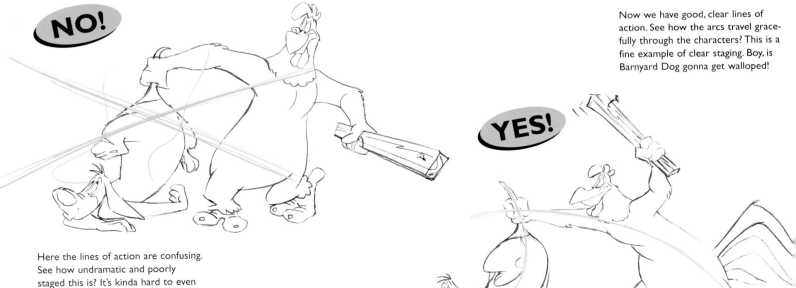

Here the lines of action are confusing. See how undramatic and poorly staged this is? It's kinda hard to even tell what's going on, isn't it?

NOW YOU'RE STARTING TO GET IT!

OK, you're doing great. Keep drawing! Don't panic! Stay loose! When you're ready, stare into the hypnotic gaze of the Great Bugzini and repeat after him . . .

i (STATE YOUR NAME) WILL HAVE FUN DRAWING AND WILL ENTERTAIN OTHERS WITH MY SILLY DRAWINGS!

Good job!
You made it through basic training. Now on to the next page!

EXPRESSIONS

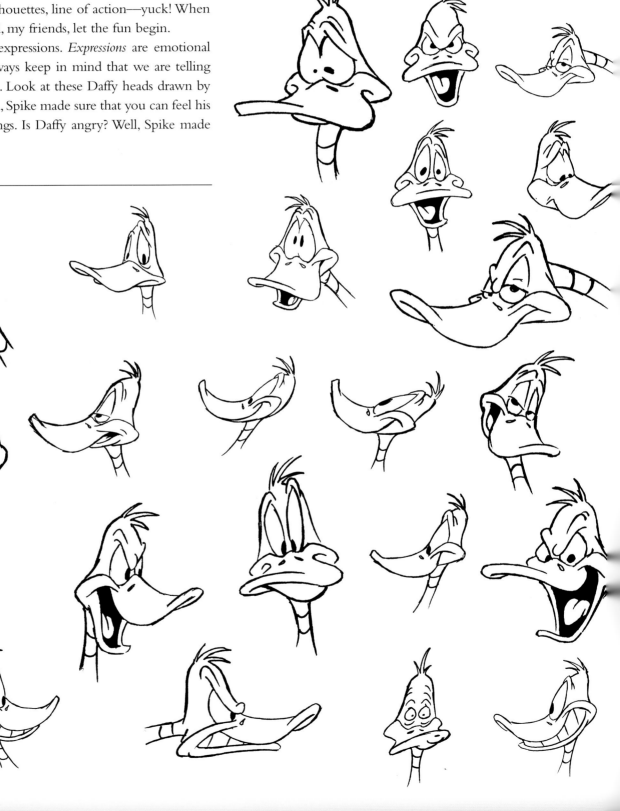

I'll bet your head is about to burst with all these art theories! Basic forms, perspective, silhouettes, line of action—yuck! When do we have some fun? Well, my friends, let the fun begin.

Let's start by studying expressions. *Expressions* are emotional character drawings, and always keep in mind that we are telling stories with these drawings. Look at these Daffy heads drawn by Spike Brandt. If Daffy is sad, Spike made sure that you can feel his sadness through the drawings. Is Daffy angry? Well, Spike made him even angrier!

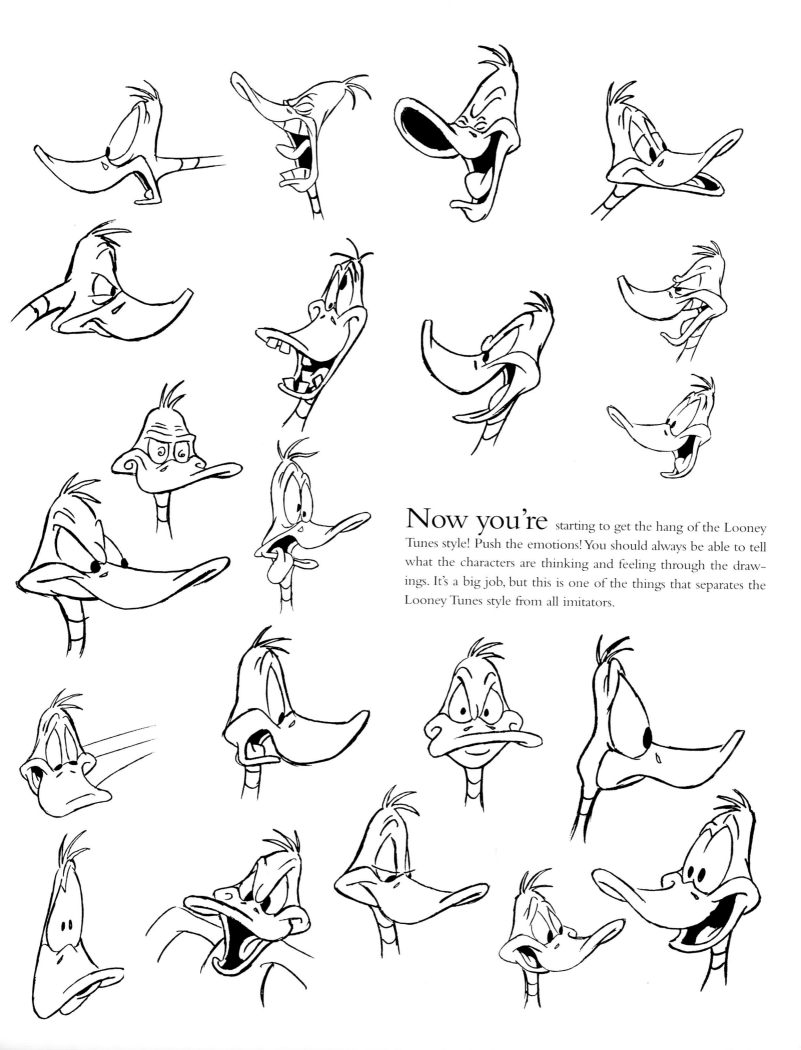

Now you're starting to get the hang of the Looney Tunes style! Push the emotions! You should always be able to tell what the characters are thinking and feeling through the drawings. It's a big job, but this is one of the things that separates the Looney Tunes style from all imitators.

2

Introducing to the public

for the very first time … the official Looney Tunes character model sheets! These are the very same model sheets that the top-drawer animators at Warner Bros. use to create knee-slapping tomfoolery!

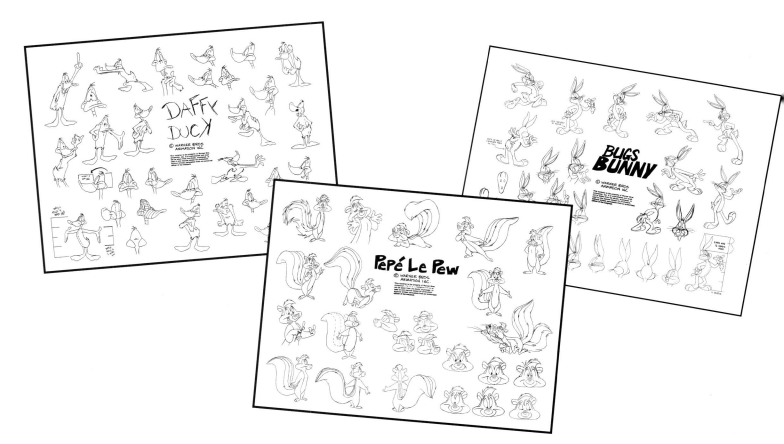

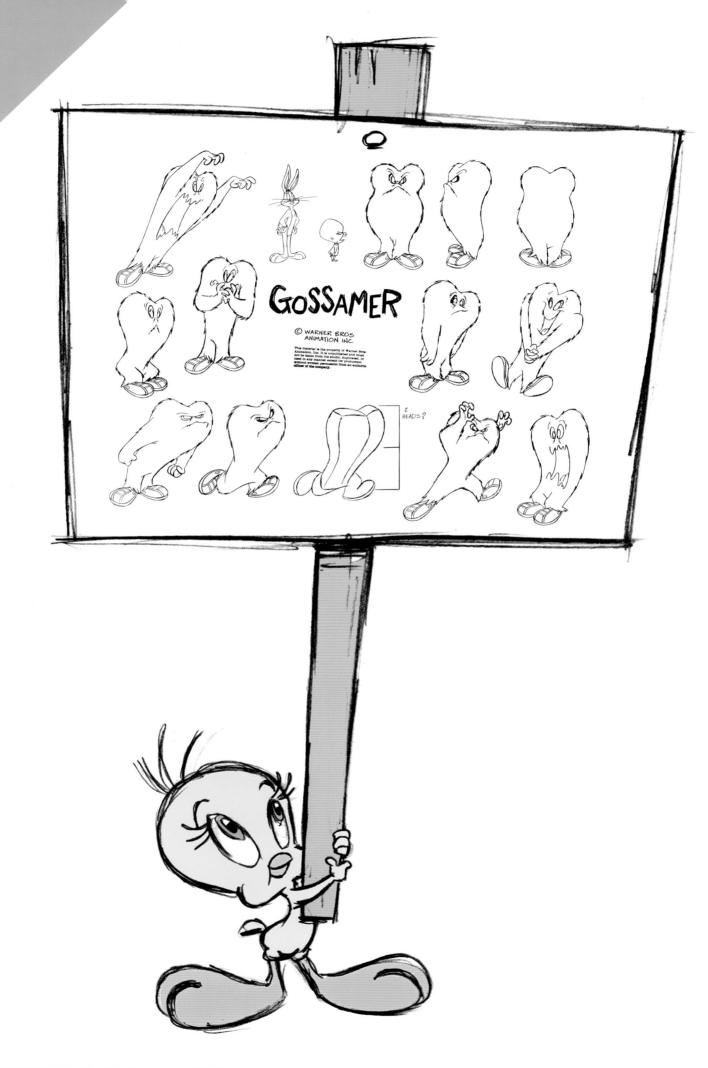

BUGS BUNNY

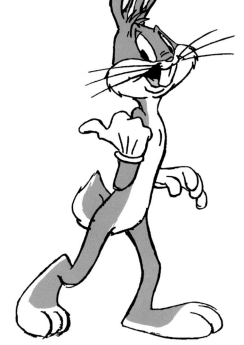

Take a look at these Bugs heads drawn by Spike Brandt (with a little help from yours truly). See how the eyes and teeth and muzzle work together in perspective? Then check out the drawings on the model sheet on the opposite page. (A *model sheet* is a bunch of drawings of a character from a lot of different angles and with a lot of different expressions.) Neat, huh? But be careful, young cartoonist; with great model sheets comes great danger! You see, this is how a couple of cartoonists decided to draw Bugs one day, looking at how some other cartoonists had decided to draw Bugs one day. On another day they all might draw differently! Model sheets are a great way to see how a character is drawn, but you also have to draw the character yourself!

There is no absolute way to draw anything correctly. Different cartoonists draw Bugs differently, but if the attitude and spirit are right, Bugs lives! So don't just copy model sheets and think that you're done. Change them and invent new funny drawings! Learn to improvise and experiment. Exaggerate! Explore! Don't be afraid to screw up!

BUGS'
COLOR
PALETTE

So here is a basic Bugs model sheet. We get to see the "waskally wabbit" drawn from a variety of angles, so we get a sense of his proportions. This is a good selection of expressions drawn from across his career. Practice drawing these, but don't forget: It's just the beginning!

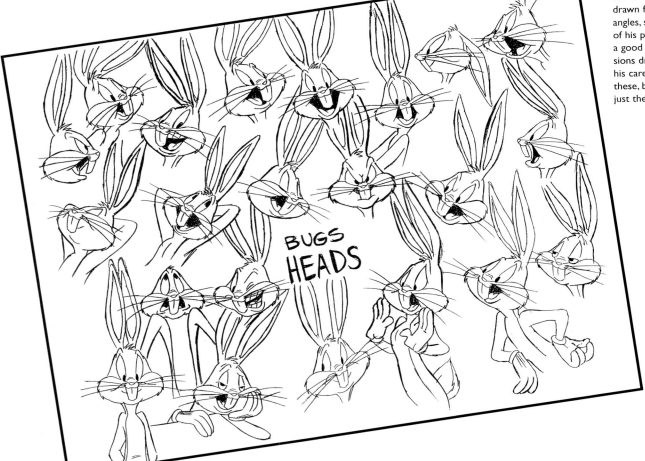

BUGS
HEADS

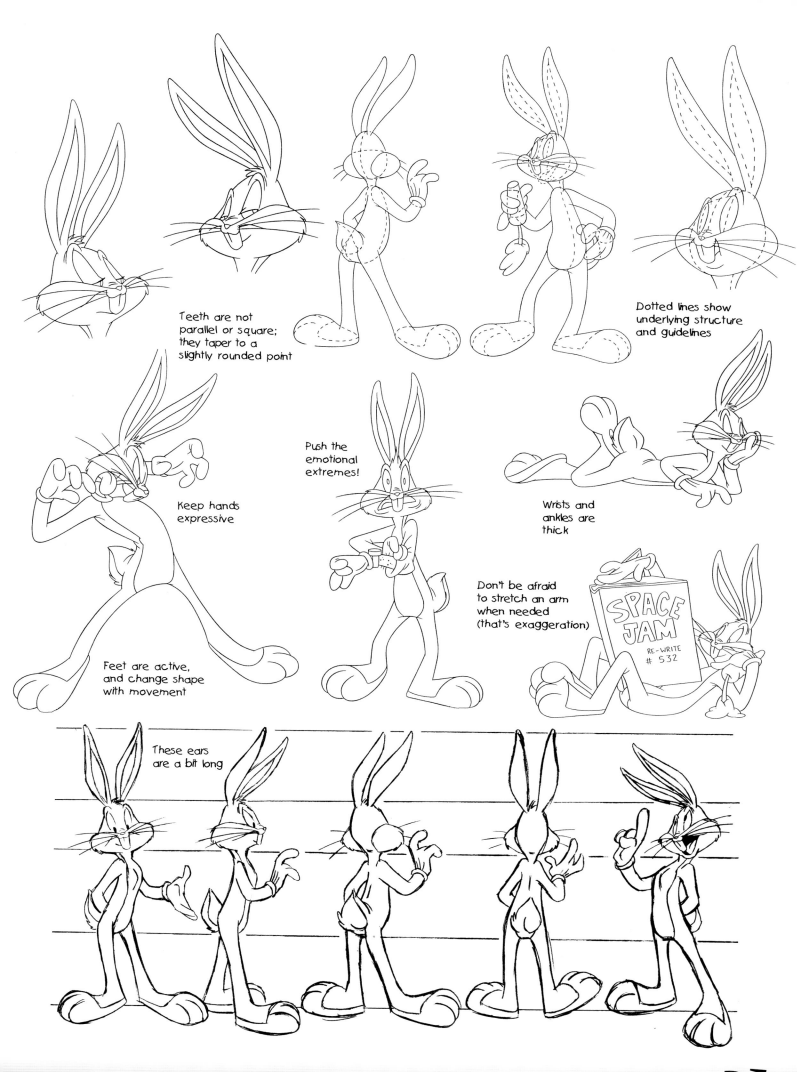

Teeth are not parallel or square; they taper to a slightly rounded point

Dotted lines show underlying structure and guidelines

Keep hands expressive

Push the emotional extremes!

Wrists and ankles are thick

Feet are active, and change shape with movement

Don't be afraid to stretch an arm when needed (that's exaggeration)

SPACE JAM
RE-WRITE # 532

These ears are a bit long

DAFFY DUCK

It's everyone's favorite second banana—Daffy Duck! (Don't tell him I said that; he'd blow a gasket!) Check out Daffy's basic forms. Use these forms to get started, and then get more complicated later. Arrange and use at will!

DAFFY'S COLOR PALETTE

Keep ankles thick!

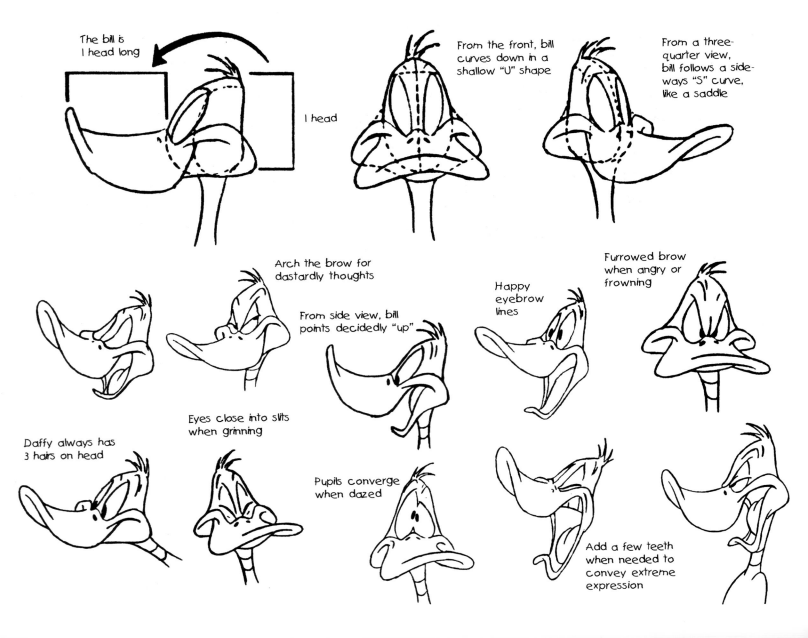

The bill is 1 head long

1 head

From the front, bill curves down in a shallow "U" shape

From a three-quarter view, bill follows a sideways "S" curve, like a saddle

Arch the brow for dastardly thoughts

From side view, bill points decidedly "up"

Happy eyebrow lines

Furrowed brow when angry or frowning

Eyes close into slits when grinning

Daffy always has 3 hairs on head

Pupils converge when dazed

Add a few teeth when needed to convey extreme expression

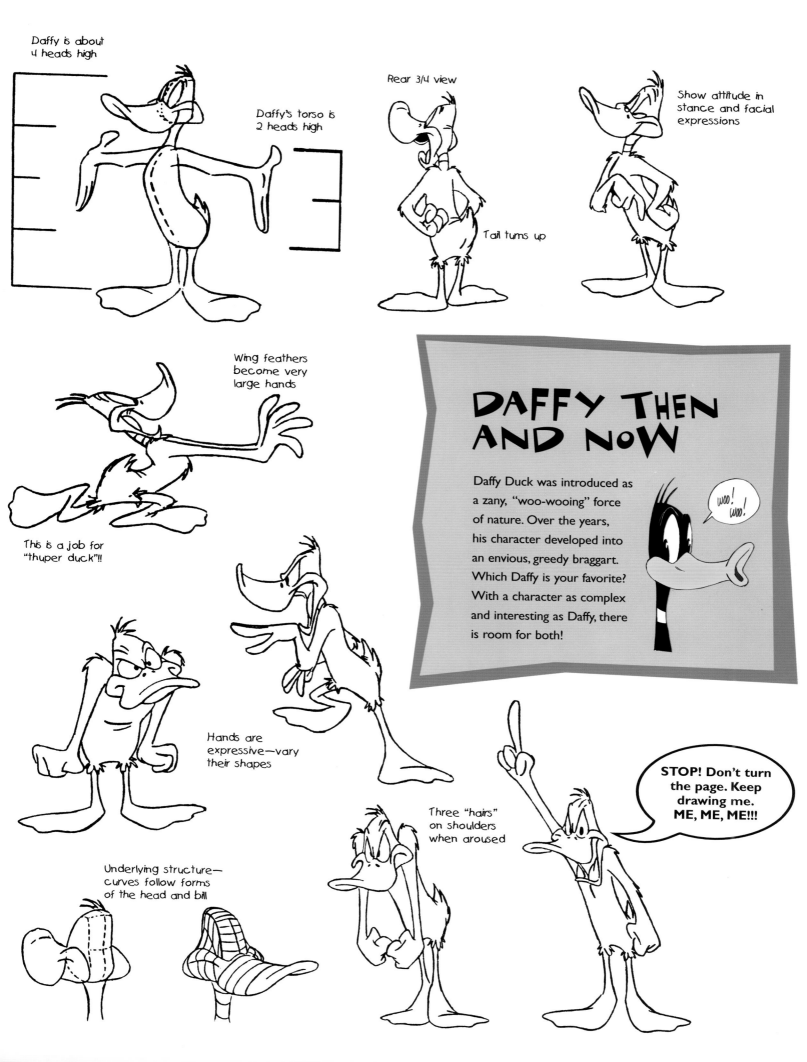

Daffy is about 4 heads high

Daffy's torso is 2 heads high

Rear 3/4 view

Tail turns up

Show attitude in stance and facial expressions

Wing feathers become very large hands

This is a job for "thuper duck"!!

DAFFY THEN AND NOW

Daffy Duck was introduced as a zany, "woo-wooing" force of nature. Over the years, his character developed into an envious, greedy braggart. Which Daffy is your favorite? With a character as complex and interesting as Daffy, there is room for both!

woo! woo!

Hands are expressive—vary their shapes

Three "hairs" on shoulders when aroused

STOP! Don't turn the page. Keep drawing me. ME, ME, ME!!!

Underlying structure— curves follow forms of the head and bill

Lola Bunny

Hey, folks—it's that "hare with no compare," Lola Bunny! Lola was introduced in the 1996 feature film *Space Jam*. That makes her the newest addition to the Looney Tunes.

LOLA'S COLOR PALETTE

Lola's ears are soft and floppy

Belly line continues under shirt

Lola has eyebrows, not eye ridges

Bottom of foot detail

Lola's footpad is a slipper shape—it doesn't extend around foot the way Bugs' does

Powder-puff tail

Practice with rough sketches to keep drawings fluid and free

Lola's hands and feet are small and petite

Only 3 lashes at the outer corners of each eyes

ELMER FUDD

Here's that woodland wacko, Elmer Fudd! Elmer started his career as a character named "Egghead," but he quickly evolved into the bald little guy we all know and love.

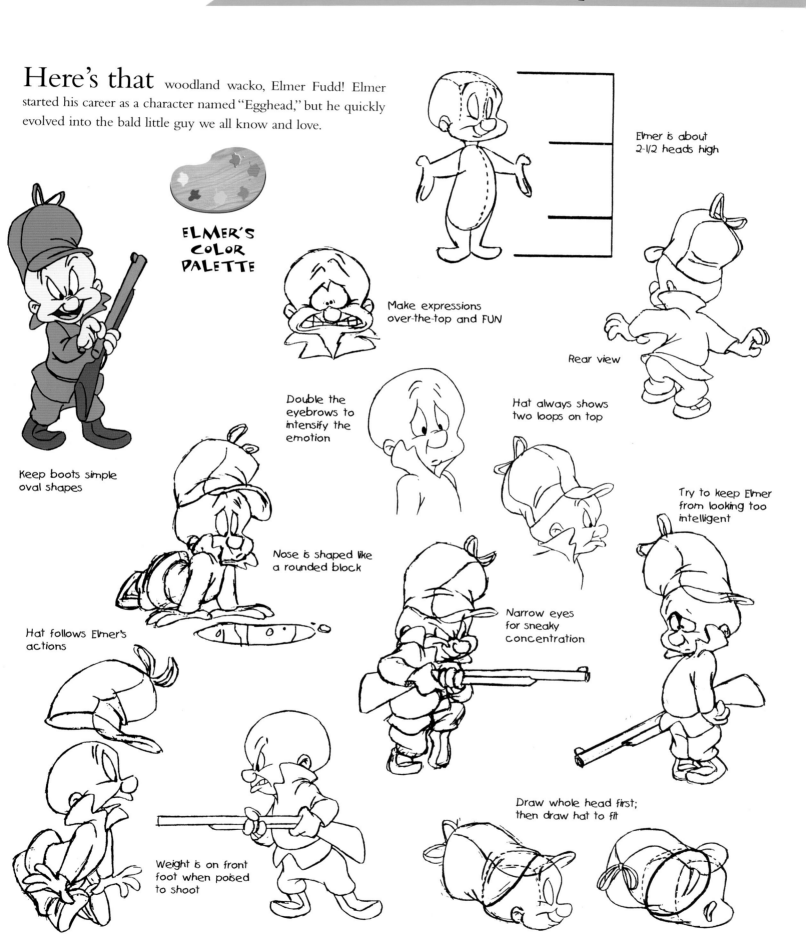

ELMER'S COLOR PALETTE

Elmer is about 2-1/2 heads high

Make expressions over-the-top and FUN

Rear view

Double the eyebrows to intensify the emotion

Hat always shows two loops on top

Keep boots simple oval shapes

Try to keep Elmer from looking too intelligent

Hat follows Elmer's actions

Nose is shaped like a rounded block

Narrow eyes for sneaky concentration

Weight is on front foot when poised to shoot

Draw whole head first; then draw hat to fit

SYLVESTER

Tweety and Sylvester have been entertaining kids and adults alike for generations. In fact, they are two of Warner Bros.' most popular characters. There is nothing like the combination of a sweet innocent and a hungry buffoon to induce laughter. Try to think up new ways for Sylvester to try to catch Tweety. It's fun!

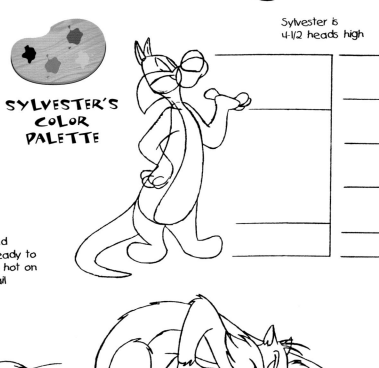

SYLVESTER'S
COLOR
PALETTE

Sylvester is 4-1/2 heads high

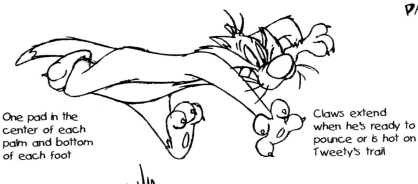

One pad in the center of each palm and bottom of each foot

Claws extend when he's ready to pounce or is hot on Tweety's trail

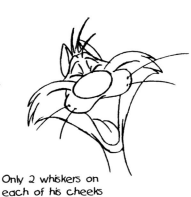

Cheeks end in 3 triangular sections of fur

Only 2 whiskers on each of his cheeks

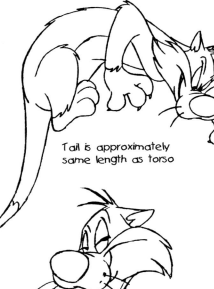

Tail is approximately same length as torso

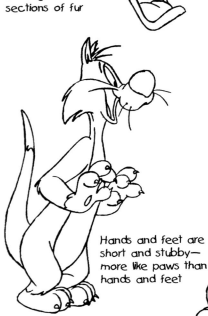

Hands and feet are short and stubby— more like paws than hands and feet

Use claws as needed

Show teeth when mouth is wide or in a snarl

TWEETY'S COLOR PALETTE

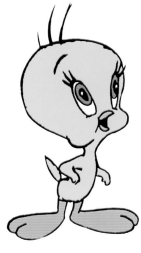

TWEETY

Some of the notes on these model sheets were written by cartoonists many, many years ago. Hey, when something works, go with it!

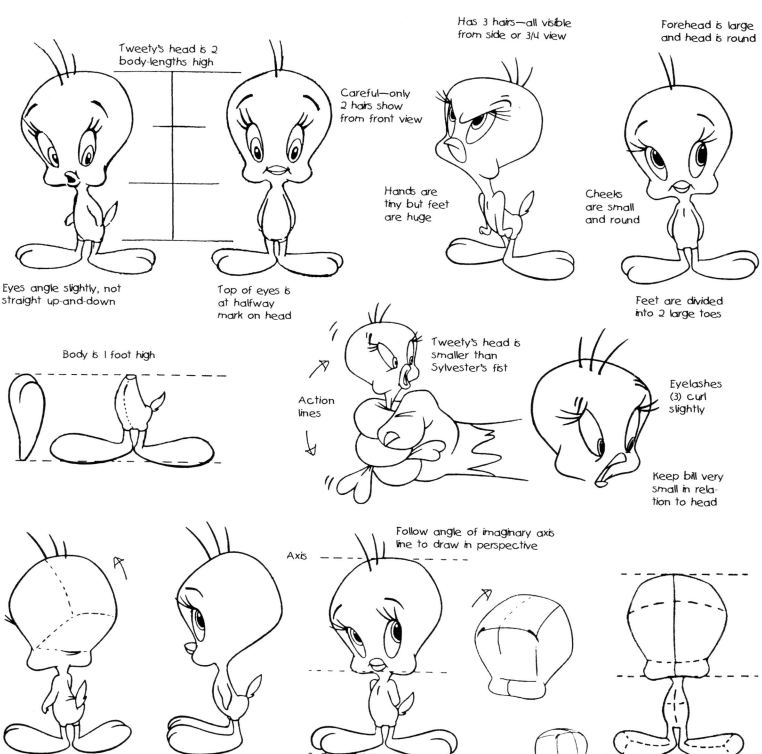

Tweety's head is 2 body-lengths high

Eyes angle slightly, not straight up-and-down

Top of eyes is at halfway mark on head

Has 3 hairs—all visible from side or 3/4 view

Careful—only 2 hairs show from front view

Hands are tiny but feet are huge

Forehead is large and head is round

Cheeks are small and round

Feet are divided into 2 large toes

Body is 1 foot high

Action lines

Tweety's head is smaller than Sylvester's fist

Eyelashes (3) curl slightly

Keep bill very small in relation to head

Axis

Follow angle of imaginary axis line to draw in perspective

WILE E. COYOTE

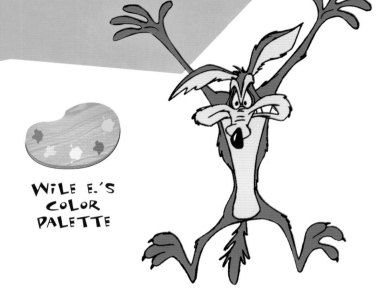

The best cartoons poke fun at the frailties and foibles of the human condition and make us laugh at ourselves. In my humble opinion, few animated characters illustrate the very human condition of single-minded obsession better than Wile E. Coyote. At some point, hunger stopped being his motivation for catching the bird, and fierce determination took over. Do you think he will ever catch Road Runner? Me neither, but I do know that he will never give up.

WILE E.'S
COLOR
PALETTE

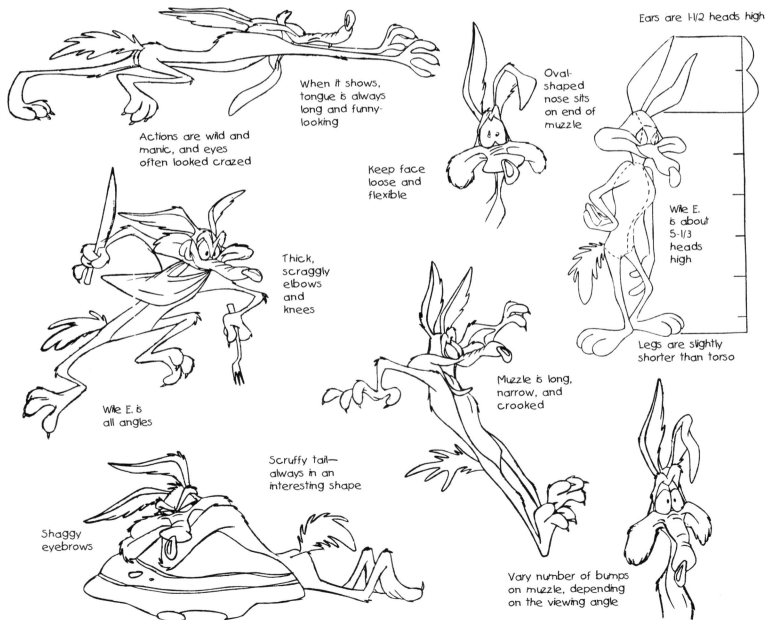

When it shows, tongue is always long and funny-looking

Actions are wild and manic, and eyes often looked crazed

Keep face loose and flexible

Thick, scraggly elbows and knees

Wile E. is all angles

Scruffy tail—always in an interesting shape

Shaggy eyebrows

Oval-shaped nose sits on end of muzzle

Ears are 1-1/2 heads high

Wile E. is about 5-1/3 heads high

Legs are slightly shorter than torso

Muzzle is long, narrow, and crooked

Vary number of bumps on muzzle, depending on the viewing angle

ROAD RUNNER

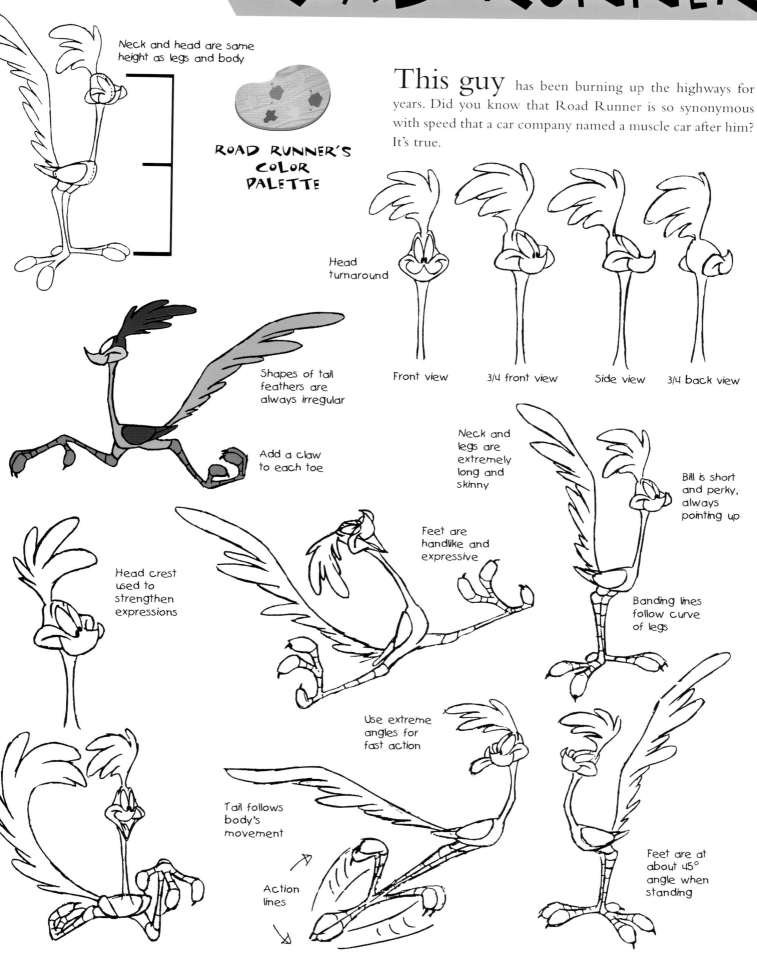

Neck and head are same height as legs and body

ROAD RUNNER'S COLOR PALETTE

This guy has been burning up the highways for years. Did you know that Road Runner is so synonymous with speed that a car company named a muscle car after him? It's true.

Head turnaround

Front view 3/4 front view Side view 3/4 back view

Shapes of tail feathers are always irregular

Add a claw to each toe

Neck and legs are extremely long and skinny

Bill is short and perky, always pointing up

Feet are handlike and expressive

Banding lines follow curve of legs

Head crest used to strengthen expressions

Use extreme angles for fast action

Tail follows body's movement

Action lines

Feet are at about 45° angle when standing

FOGHORN LEGHORN

Did you kids ever take a good look at Foghorn? DANG! That is one big rooster! Don't be afraid to emphasize his girth. Foghorn enjoys "livin' large."

Foghorn is 12-2/3 heads high

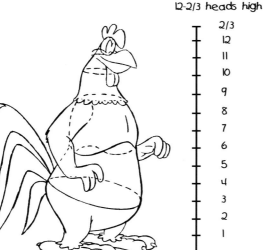

FOGHORN'S COLOR PALETTE

4-2/3 heads from ruff to crest

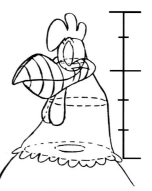

Bottom of neck ruff has small, irregular scallops

Upper half of bill is slightly longer than lower half

Foghorn is chunky—keep body wide

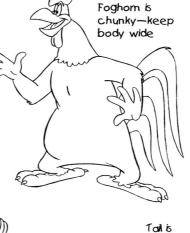

Crest is 3 rounded loops

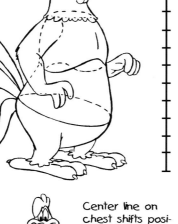

Center line on chest shifts position depending on viewing angle

Keep waddle against neck— don't let it hang free

Tail is 3 large feathers

Feet have 2 toes in front and 1 in back, and all have short claws

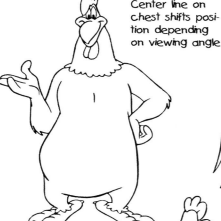

Center line on back indicates shoulder blades

Hands are large and humanlike

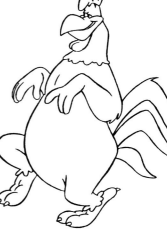

YOSEMITE SAM

Who let this guy in here? I guess that every hero needs a bad guy, so here is a no-goodnik who has been driving Bugs crazy for years.

YOSEMITE'S COLOR PALETTE

Sam is about 3 heads high

Feet are miniscule and beard is HUGE

Standard Sam has full head of hair under his hat

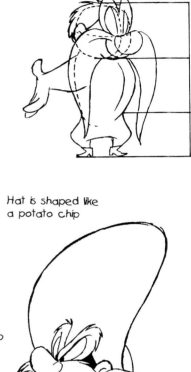

Beard line starts at mid-eye and extends almost to the ground

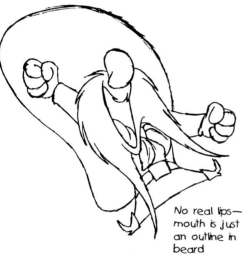

No real lips— mouth is just an outline in beard

Hat is shaped like a potato chip

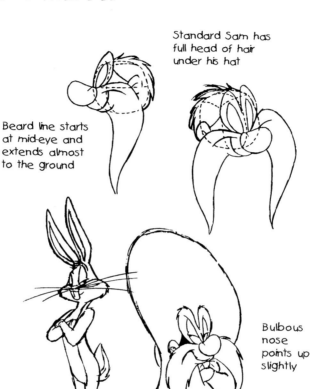

Bulbous nose points up slightly

Bowed legs

Including hat, Sam is almost as tall as Bugs— without it, he comes only to Bugs' shoulders

Belt buckle is Texas-sized

Keep hat shapes simple

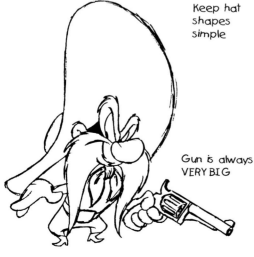

Gun is always VERY BIG

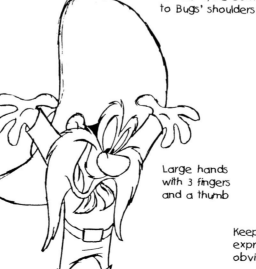

Large hands with 3 fingers and a thumb

Keep expressions obvious

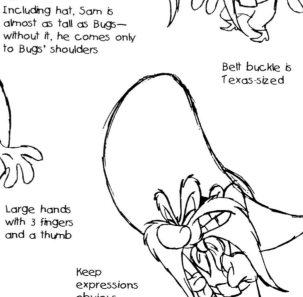

THE TASMANIAN DEVIL

TAZ'S COLOR PALETTE

Almost everyone loves Taz! He's really fun to draw—all teeth and fur! Try to draw the meanest and craziest Taz you can.

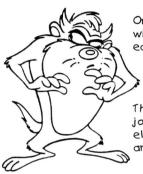

Only 2 whiskers on each cheek

Thicker joints at elbows and knees

Taz is only as high as Bugs' chest

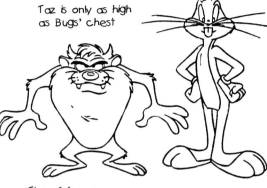

Tips of fur are slightly rounded

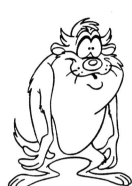

Nose is shaped like a doorknob

Round ears below pointed, crescent-shaped horns

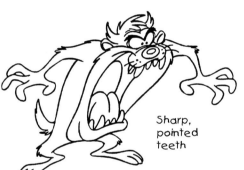

Sharp, pointed teeth

Taz is about 3 heads high

Keep 3 tufts of hair on top of head distinct from horns

Keep nose and reflection on nose in perspective

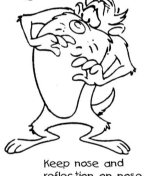

THE TORNADO EFFECT

These days, in the digital age of the 21st century, Taz's tornado has become quite a complicated special effect. Modern animators use the same intricate computer tricks that fancy special-effects artists use to make Taz's tornado seem more "real." These tricks also make Taz appear more ferocious than ever.

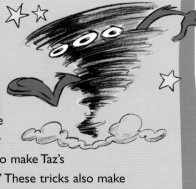

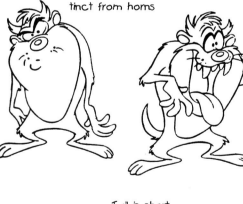

Open mouth nearly fills whole face

Tail is short, upright, and pointed

38

MARViN THE MARTiAN & K-9

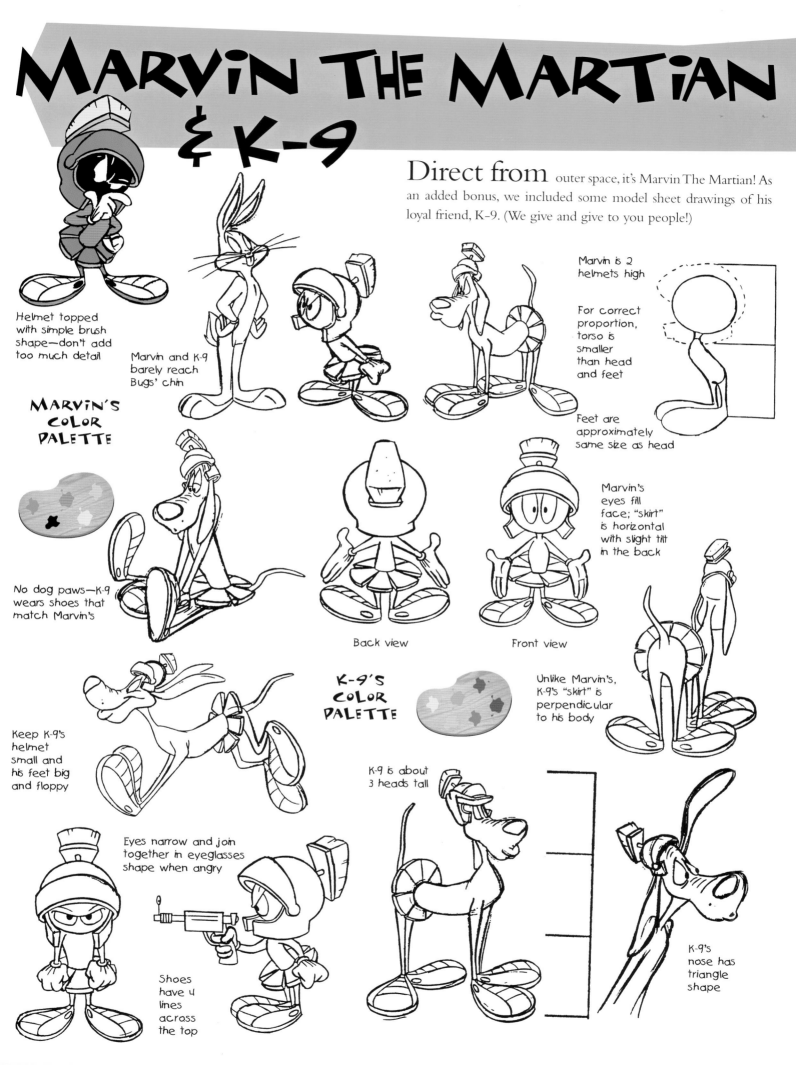

Direct from outer space, it's Marvin The Martian! As an added bonus, we included some model sheet drawings of his loyal friend, K-9. (We give and give to you people!)

Helmet topped with simple brush shape—don't add too much detail

Marvin and K-9 barely reach Bugs' chin

MARVIN'S COLOR PALETTE

No dog paws—K-9 wears shoes that match Marvin's

Marvin is 2 helmets high

For correct proportion, torso is smaller than head and feet

Feet are approximately same size as head

Back view

Front view

Marvin's eyes fill face; "skirt" is horizontal with slight tilt in the back

K-9'S COLOR PALETTE

Unlike Marvin's, K-9's "skirt" is perpendicular to his body

Keep K-9's helmet small and his feet big and floppy

K-9 is about 3 heads tall

Eyes narrow and join together in eyeglasses shape when angry

Shoes have 4 lines across the top

K-9's nose has triangle shape

PUSSYFOOT & MARC ANTONY

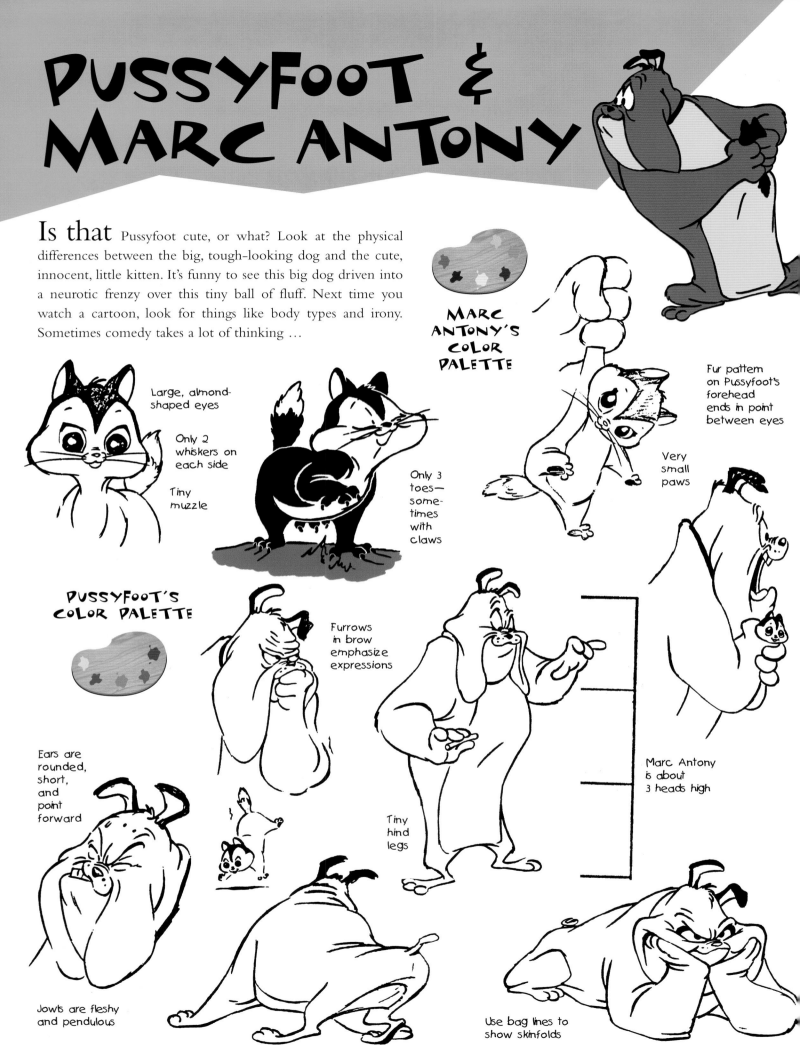

Is that Pussyfoot cute, or what? Look at the physical differences between the big, tough-looking dog and the cute, innocent, little kitten. It's funny to see this big dog driven into a neurotic frenzy over this tiny ball of fluff. Next time you watch a cartoon, look for things like body types and irony. Sometimes comedy takes a lot of thinking …

MARC ANTONY'S COLOR PALETTE

Large, almond-shaped eyes

Only 2 whiskers on each side

Tiny muzzle

Only 3 toes—sometimes with claws

Fur pattern on Pussyfoot's forehead ends in point between eyes

Very small paws

PUSSYFOOT'S COLOR PALETTE

Furrows in brow emphasize expressions

Ears are rounded, short, and point forward

Marc Antony is about 3 heads high

Tiny hind legs

Jowls are fleshy and pendulous

Use bag lines to show skinfolds

PEPE LE PEW & LE CAT
(A.K.A. PENELOPE)

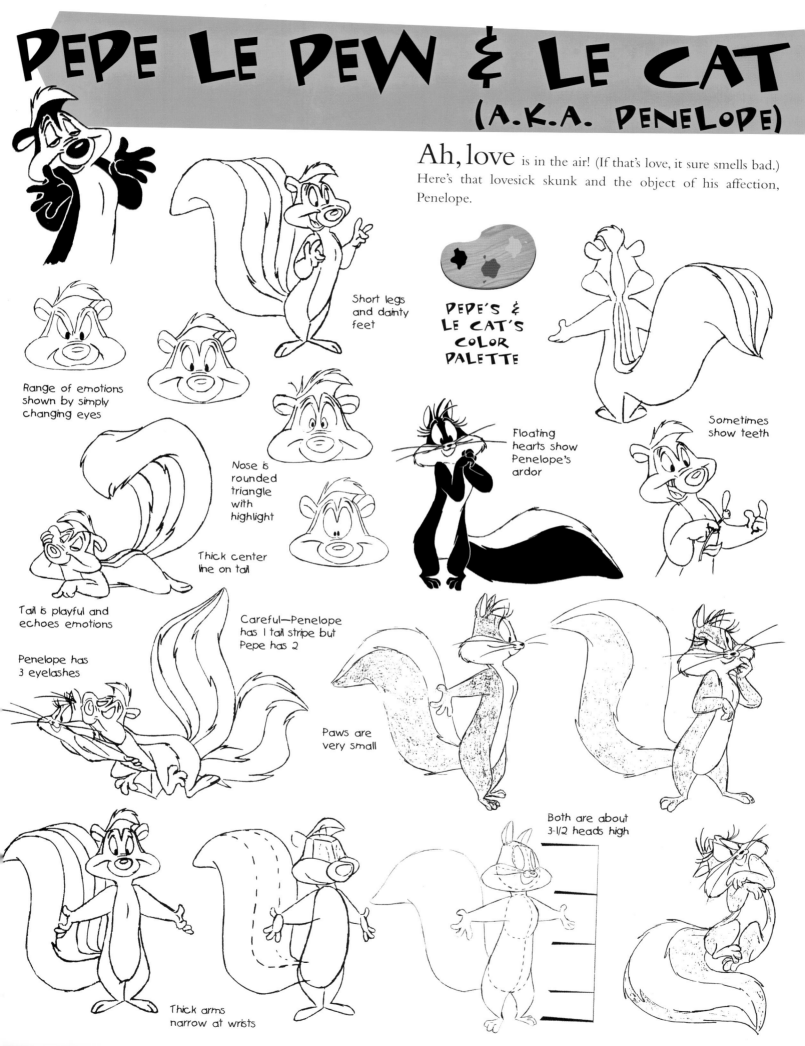

Ah, love is in the air! (If that's love, it sure smells bad.) Here's that lovesick skunk and the object of his affection, Penelope.

Short legs and dainty feet

PEPE'S & LE CAT'S COLOR PALETTE

Range of emotions shown by simply changing eyes

Sometimes show teeth

Nose is rounded triangle with highlight

Floating hearts show Penelope's ardor

Thick center line on tail

Tail is playful and echoes emotions

Penelope has 3 eyelashes

Careful—Penelope has 1 tail stripe but Pepe has 2

Paws are very small

Both are about 3-1/2 heads high

Thick arms narrow at wrists

PORKY PIG

PORKY'S COLOR PALETTE

Porky Pig is a great character, and he's been around for years. Did you know that Porky was Warner Bros.' first major cartoon star? Well, he was! Have fun drawing this little guy!

Draw inner ear lines parallel to outer lines

Ears are small and pointed

Features similar to Tweety's—round head, round cheeks, small mouth

Jacket flies up when running, not flat on back

Shape of head is close to a true circle

Nose is rounded triangle with 2 teardrop nostrils

Always 2 eye-brow lines

Porky is about 2-1/3 heads high—but that's not a rigid rule

Ears are set back on head

"Hams" extend out beyond basic bean shape of body

Mouth sets in under cheeks

Don't forget—Porky wears a small, triangular-shaped bow tie

Top of cheek curves under base of eye

Bottoms of feet are oval, not round

Jacket is simple and follows contours of body

Cute, curly tail and short, stubby legs

Follow construction lines to know where to place features

SPEEDY GONZALES

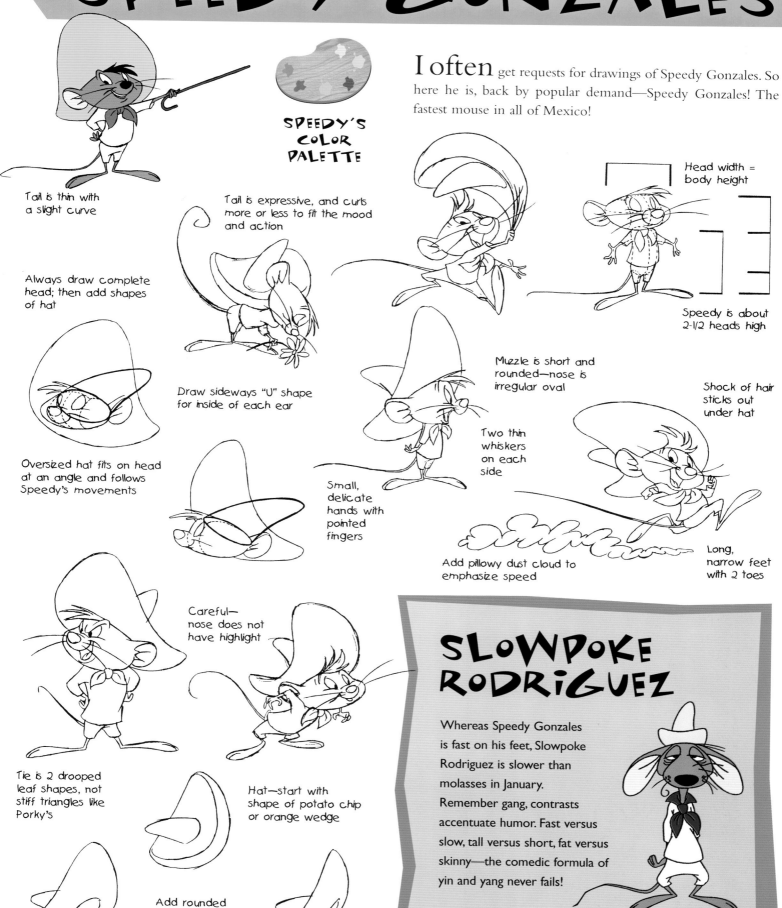

SPEEDY'S COLOR PALETTE

I often get requests for drawings of Speedy Gonzales. So here he is, back by popular demand—Speedy Gonzales! The fastest mouse in all of Mexico!

Tail is thin with a slight curve

Tail is expressive, and curls more or less to fit the mood and action

Always draw complete head; then add shapes of hat

Oversized hat fits on head at an angle and follows Speedy's movements

Draw sideways "U" shape for inside of each ear

Head width = body height

Speedy is about 2-1/2 heads high

Muzzle is short and rounded—nose is irregular oval

Shock of hair sticks out under hat

Two thin whiskers on each side

Small, delicate hands with pointed fingers

Add pillowy dust cloud to emphasize speed

Long, narrow feet with 2 toes

Careful— nose does not have highlight

Tie is 2 drooped leaf shapes, not stiff triangles like Porky's

Hat—start with shape of potato chip or orange wedge

Add rounded triangle for crown

SLOWPOKE RODRIGUEZ

Whereas Speedy Gonzales is fast on his feet, Slowpoke Rodriguez is slower than molasses in January. Remember gang, contrasts accentuate humor. Fast versus slow, tall versus short, fat versus skinny—the comedic formula of yin and yang never fails!

SUPPORTING CAST

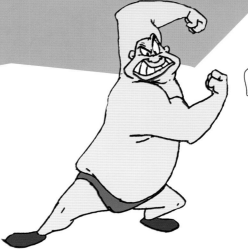

Here is a sampling of just a few of the Looney Tunes "supporting characters." I'm sorry, I shouldn't call these guys and gals "supporting characters"; many are the stars of their own cartoons. We at Warner Bros. are very lucky and privileged to have such a rich and diverse cast of characters to draw from. Why, if a baseball team had as strong a bench as we have, they would win the World Series for centuries!

THE CRUSHER

Short, stumpy legs, thicker at thighs

GOSSAMER

Arms usually fold into body at sides, but sometimes Gossamer does have hands

HENERY HAWK

Keep chest thrust forward

WITCH HAZEL

Tiny legs and feet

BARNYARD DOG

Large hands and big lower lip

THE PENGUIN

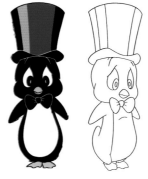

Large, expressive eyes

BULL

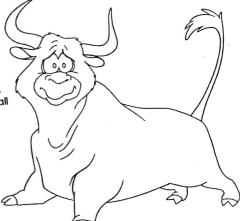

Body is massive, but legs are small

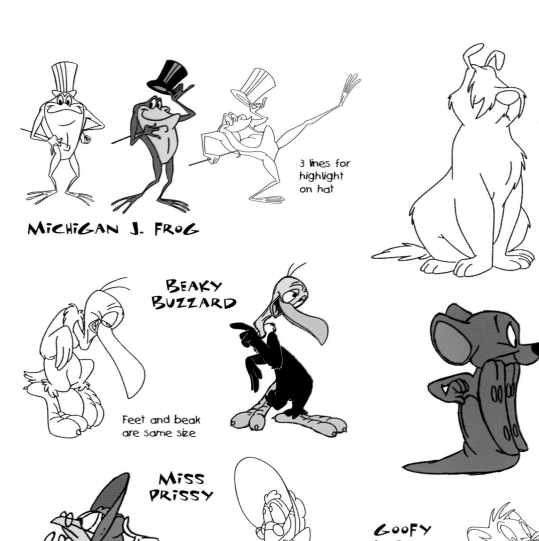

MICHIGAN J. FROG

3 lines for highlight on hat

SAM SHEEP DOG

Hair always covers eyes

BEAKY BUZZARD

Feet and beak are same size

HIPPETY HOPPER

REALLY big feet!

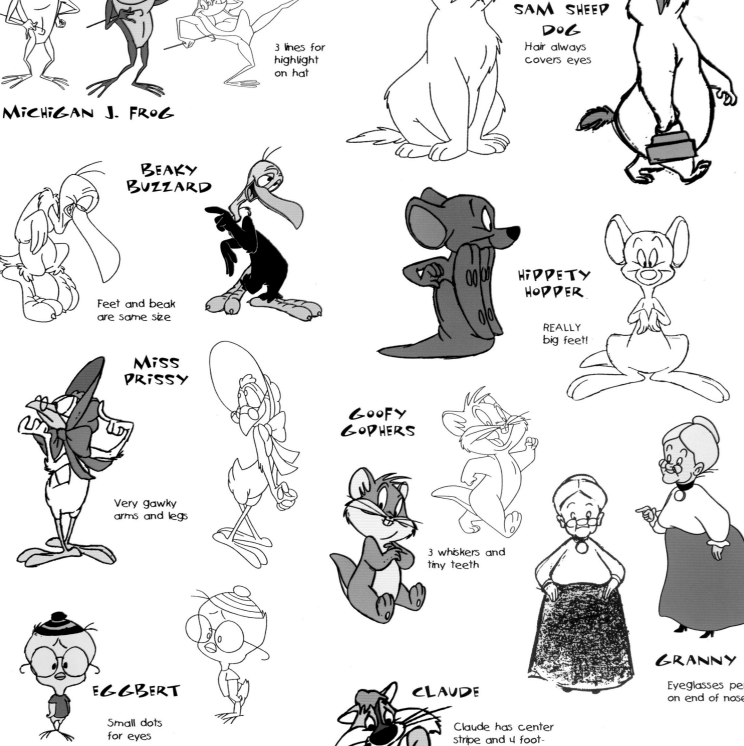

MISS PRISSY

Very gawky arms and legs

GOOFY GOPHERS

3 whiskers and tiny teeth

GRANNY

Eyeglasses perch on end of nose

EGGBERT

Small dots for eyes

CLAUDE

Claude has center stripe and 4 foot-pads on each paw

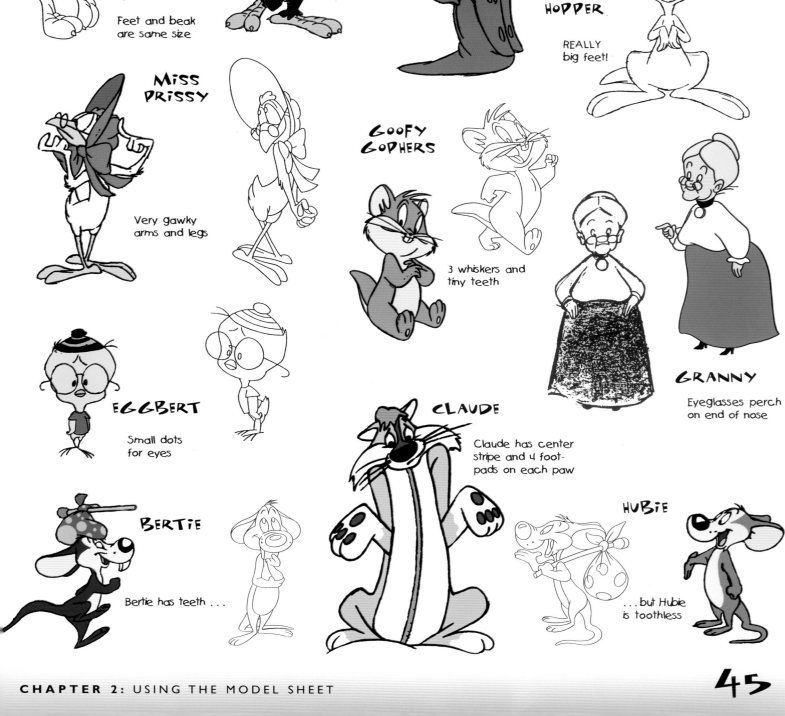

BERTIE

Bertie has teeth . . .

HUBIE

. . . but Hubie is toothless

3 THE STORY PROCESS

So, you might ask, "It's OK to draw funny pictures, but where do all those loony ideas come from?" Well, they originate in many different ways. Sometimes the director might get a good idea while taking a shower, or an assistant animator might think up something funny during lunch. One time, a cranky old boss told the animators, "Don't make any cartoons with bullfights." So what did the animators do? They made *Bully for Bugs*, one of the funniest Bugs Bunny cartoons ever.

Once you have a great idea, usually your first step is to talk to a scriptwriter. Sometimes the animation team follows the script very closely; other times, the writer writes an outline, which is interpreted by a storyboard team. Then the writer basically makes the words the characters say even funnier.

No matter whom you talk to, each person will think his or her way is best, so don't worry too much. Instead, think up the funniest story you can, and then tell the story to your friends. Ask them for their ideas. It's more fun to work as a team and invent the craziest, most hilarious story you can!

THE STORYBOARD

The story artist is the first person to turn the written script into a visual blueprint on which the entire animated film will be based. That means the story artist's job is very important! The storyboard artist establishes composition, sets the pacing, and originates the characters' acting and expressions. He or she must think clearly to tell the story visually. Most directors work very closely with the story artists, and some even draw the storyboard themselves.

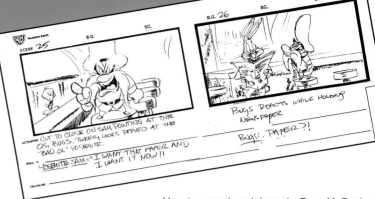

Here is a storyboard drawn by Doug McCarthy and Tim Cahill from the animated short film *Carrotblanca*. Does it tell the story clearly? Can you tell what the characters' emotions are? Are the shots composed effectively? Study these storyboards and look for other examples of storyboards printed in other animation books.

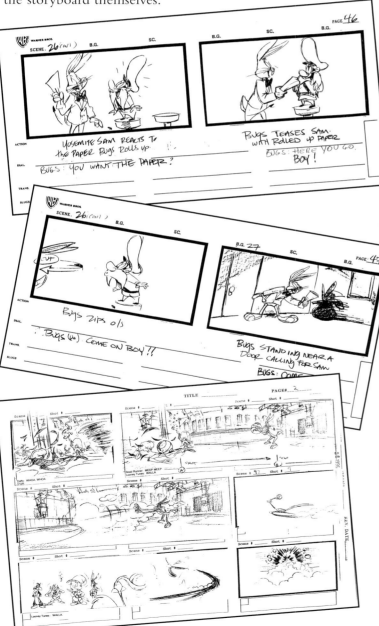

TIPS LIST

It would be easy to write an entire book on storyboarding, but here are some basic principles to remember:

1 Tell the story! Don't make the drawing too beautiful at this stage. Keep it rough. Keep it simple. Just tell the story.

2 Use composition to your advantage! You can compose a shot to help reinforce the characters' emotions or to strengthen a story point. Use sharp, dynamic angles for strong, emotional shots. High, lonely angles establish feelings of seclusion. A dramatic up-shot works for a mean, leering character. This is comedy, remember—stage funny actions clearly so the audience is never confused!

3 Acting, acting, acting! The characters are actors. Are their emotions clear to the audience? If not, strengthen their expressions. Never leave the audience guessing about what is going on. Show it to them! Here's another rule of thumb: Keep funny facial expressions in closeups and use funny body expressions in wide shots. (Duh!)

The next time you watch a Looney Tunes cartoon, think about things like composition and acting. Is it easy to follow the story? Is it clear what the character is thinking? Do you see neat camera angles used for dramatic effect? It's a lot to think about, but soon it will be second nature.

Well, I hope you are brimming with respect for the storyboard artist. Did you ever imagine that it took so many talented people to make an animated cartoon? It does! And everyone's job is important to the whole. Maybe you'll like to draw storyboards more than animating, or maybe backgrounds are your thing. If you enjoy entertaining people through your art, then chances are there is a job waiting for you somewhere in animation!

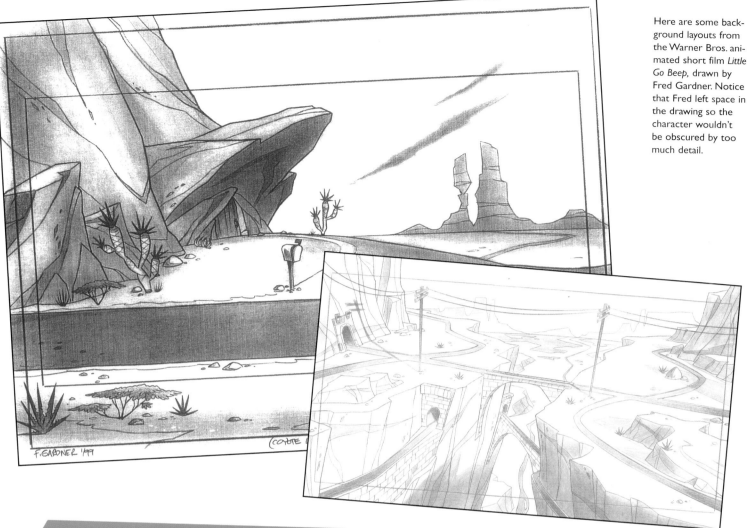

CREATING BACKGROUNDS

The background layout artist is responsible for the appearance of all the scenery in an animated film. This is the person who helps set the style of the film. He or she knows whether the backgrounds should have a "realistic feel" or whether they need a zippy, "abstract" approach. The background layout artist looks at the storyboard and then makes the individual shots more dynamic and fun to look at. He or she helps show the animator where the character is placed and how the character moves across the frame. The layout artist also determines the camera's placement in the scene, deciding whether to create higher or lower angles or when to use a more direct approach. It's important for the background layout artist to work closely with both the director and the character layout artist to make sure that everyone is on the same track and has the same results in mind.

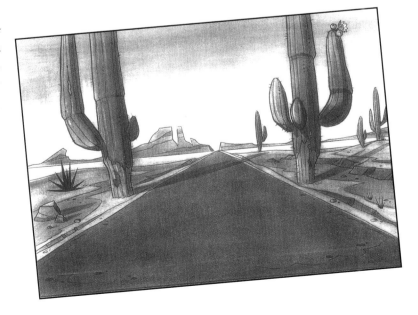

ADDING COLOR

Once the background layouts are completed, the layouts move on to the background painters, who apply color and make final, camera-ready pieces of art. Sounds easy, doesn't it? It's not. Background artists have a complex job—one that usually takes years to master. It is the background artists' job to help set the mood of the scene through color and technique, so they must be skilled enough to know what mix of colors will get the emotional effects they desire. They also need to know how to use lighting to help stage the character and create atmosphere.

In addition, the background artists have to determine how much detail needs to be rendered in the paintings. If there is too much detail, the background will draw attention away from the characters. If there is too little detail, the painting will look boring and flat, and the whole cartoon will be less interesting. The artists must also be careful with use of color. Too much intensity in the colors or too great a contrast between the lights and darks will draw the audience's attention away from the character, which is where you want the focus to be!

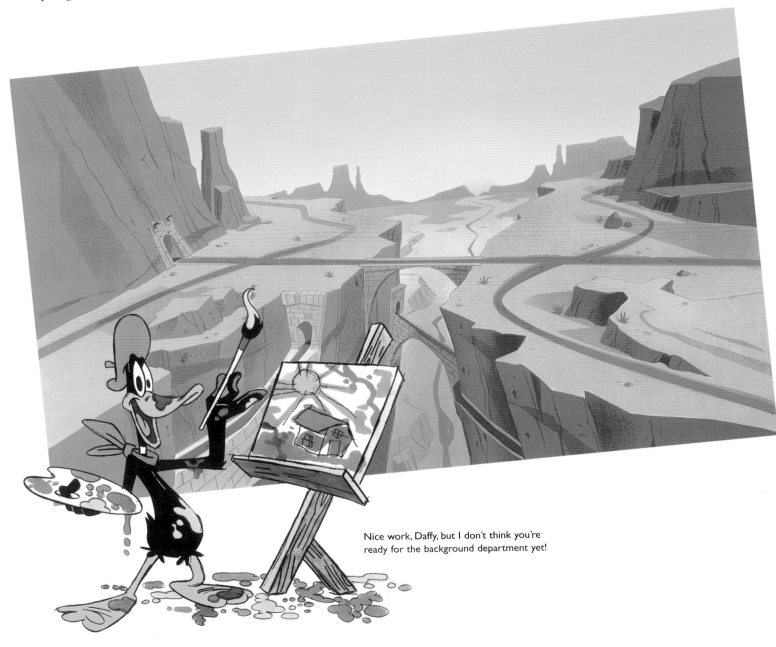

Nice work, Daffy, but I don't think you're ready for the background department yet!

MOOD AND EFFECT IN BACKGROUNDS

The background layout artists and background painters have tricky jobs setting the stage for the animators. The backgrounds must be wonderful and exciting pieces of art, but they must not overpower the animation. Ya see, for all their beauty, they are still backgrounds, and they must play second fiddle to the action. This in no way should sell these artists short. Great, classic Looney Tunes background artists like Phil De Guard, Maurice Noble, and Hawley Pratt created a distinctively energetic style that today's Warner Bros. artists work diligently to carry on.

These backgrounds were painted by the great art director Alan Bodner. Take a look at each of these paintings. They are all identifiable as Looney Tunes backgrounds, but each has a different feeling and mood. That's because they are from different cartoons that had different stories to tell. Yes, kids, the backgrounds help tell the story! At least they do in good cartoons. The next time you watch a good cartoon, pay close attention to how the backgrounds help strengthen the story.

4 CHARACTER ANIMATION

All right, cartoonists, let's

recap. You've learned the basics of cartooning, you know what a model sheet is, and you know about staging and composition and backgrounds. You have a great storyboard bursting with hilarious ideas.

Now, and only now, may you officially begin animating. Ya see, you had to learn all that other junk to even begin thinking about animation. Why? Because animation is complicated. You need a firm foundation to anchor and frame your drawings. Think about it—you're being asked to make a bunch of scribbles to create a living, breathing character capable of feeling the same emotions you feel: sadness, happiness, anger, or joy. It might be a little tricky at first—maybe more than a little tricky. But when it works, it's a satisfying art indeed.

VOICE RECORDING

The art of making the characters appear to be speaking is called "lip sync." But to animate speaking characters, the spoken words must be recorded first. That's right, the animation is always done *after* the voices are recorded. The performance of the voice actor dictates the length and pacing of the spoken track and also sets the emotional tone of the character. As you can imagine, this makes the voice actor very important! The most basic mouth shapes are illustrated below:

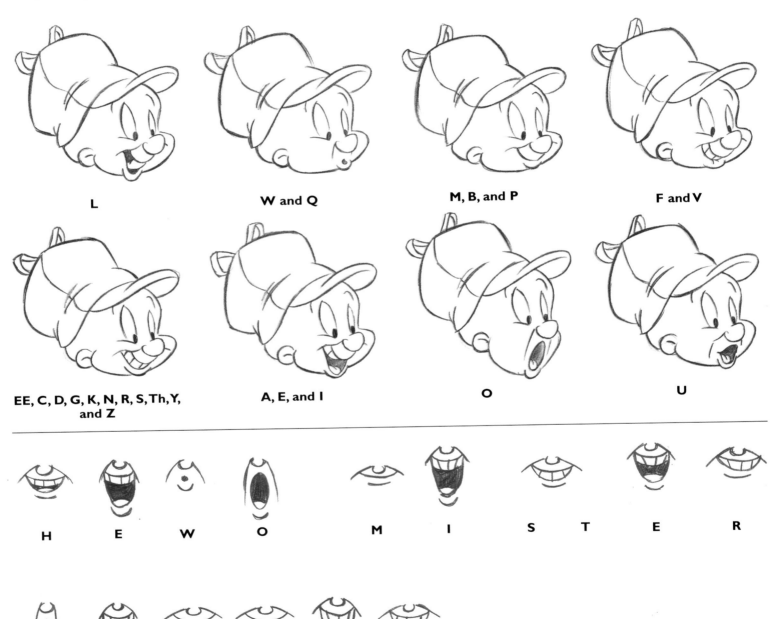

L

W and Q

M, B, and P

F and V

EE, C, D, G, K, N, R, S, Th, Y, and Z

A, E, and I

O

U

H E W O M I S T E R

W A B B I T

Here is a line spoken by that past master of "mispwonounced dia-wogue," Mr. Elmer Fudd. Can you see how the individual mouth positions make up spoken words?

DIALoGUE

Like most things in animation, animating dialogue seems simple, but in fact it requires years of hard work and practice. You see, the animator isn't just mechanically opening and closing the character's mouth to make him or her speak; the animator is actually making the character *act*. The animator must listen closely to the vocal track and bring out all its subtlety and nuances. The art of turning mouth shapes and expressions into a moving animated performance takes many years to master.

So where do you start? Start simply. Look at yourself in the mirror, and act out the dialogue. What shapes does your mouth make when you speak the words? What do your eyes do when you try to experience the character's emotions? Don't feel stupid. This exercise will really help your animation!

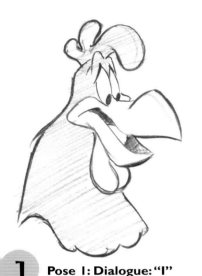

1 Pose 1: Dialogue: "I"

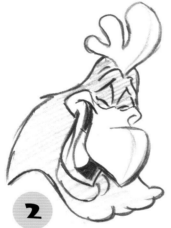

2 Head moves down to anticipate the next action dialogue: "Say"

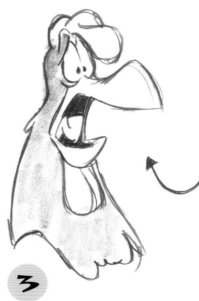

3 Big movement, change in expression, and accenting word dialogue: "What?!!"

4 Settle back into position

EXPOSURE SHEET

Once the voice track is recorded and edited, it is transcribed on exposure sheets, called "x-sheets," for short. Every line on the sheet equals one frame of film.

Let's take a look at this "x-sheet" from *Little Go Beep*. The words that run up and down are spoken by Wile E. Coyote's father, Cage E. Coyote. By knowing where the spoken words fall on which frames, the animator can make sure that Cage E. enunciates just right.

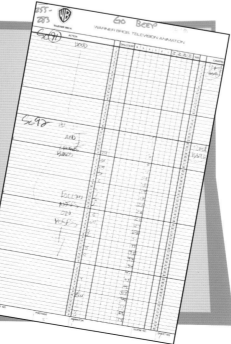

THUMBNAILS

Sometimes an animator makes small, rough (and often crude) sketches to help plan out a scene. These *thumbnails* are like visual notes; they describe the action of a scene in its broadest sense. Because you can see the whole action at once, thumbnails are a good device to use to solve problems quickly.

Take a look at these thumbnail sketches of Marvin The Martian, Bugs Bunny, and Sylvester. Can you see how the animator used the sketches to design the characters' movements? Notice how the animator kept the drawings rough and loose. Practice your own thumbnails, and try to keep them just as loose.

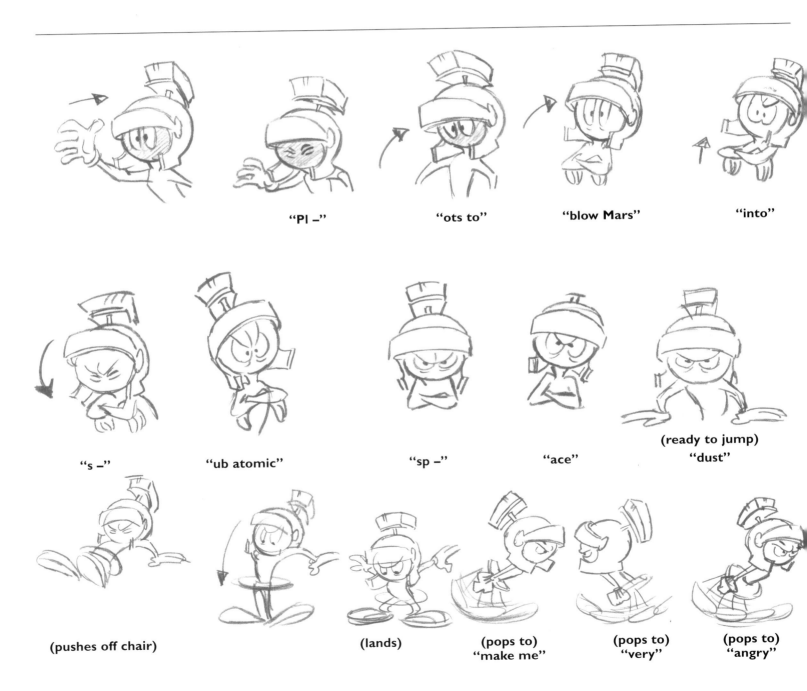

"Pl –" "ots to" "blow Mars" "into"

"s –" "ub atomic" "sp –" "ace" (ready to jump) "dust"

(pushes off chair) (lands) (pops to) "make me" (pops to) "very" (pops to) "angry"

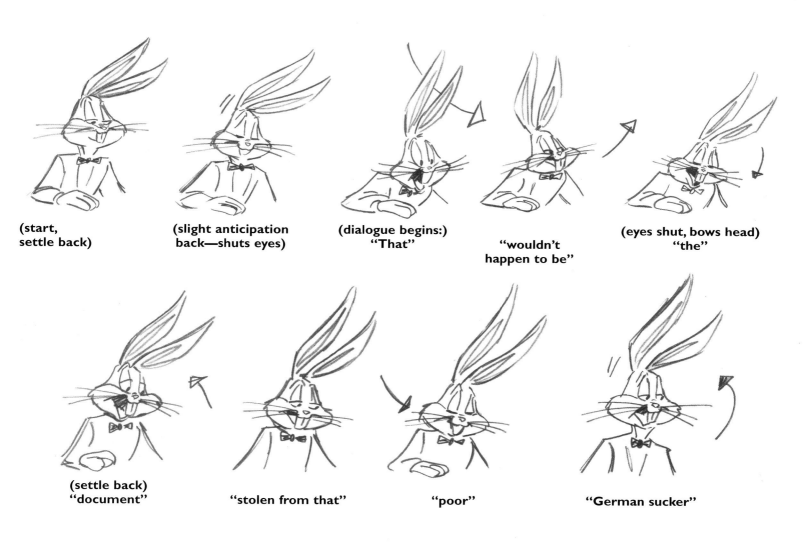

(start,
settle back)

(slight anticipation
back—shuts eyes)

(dialogue begins:)
"That"

"wouldn't
happen to be"

(eyes shut, bows head)
"the"

(settle back)
"document"

"stolen from that"

"poor"

"German sucker"

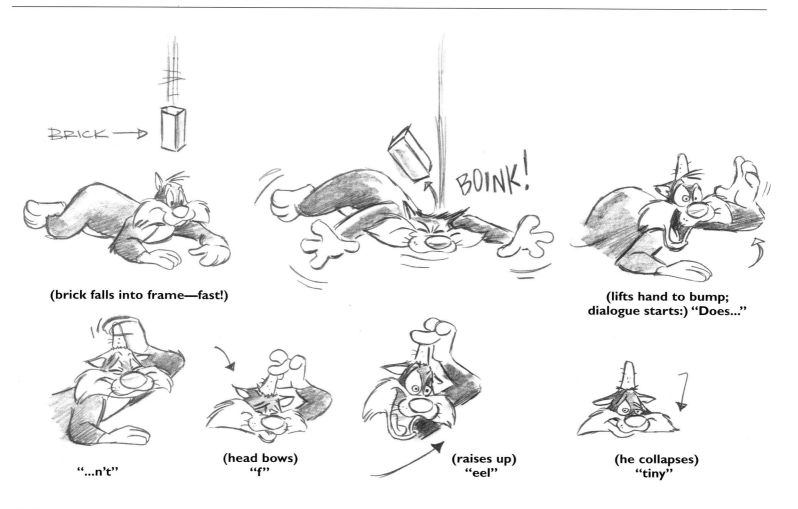

BRICK →

(brick falls into frame—fast!)

BOINK!

(lifts hand to bump;
dialogue starts:) "Does..."

"...n't"

(head bows)
"f"

(raises up)
"eel"

(he collapses)
"tiny"

THE CHARACTER LAYOUT

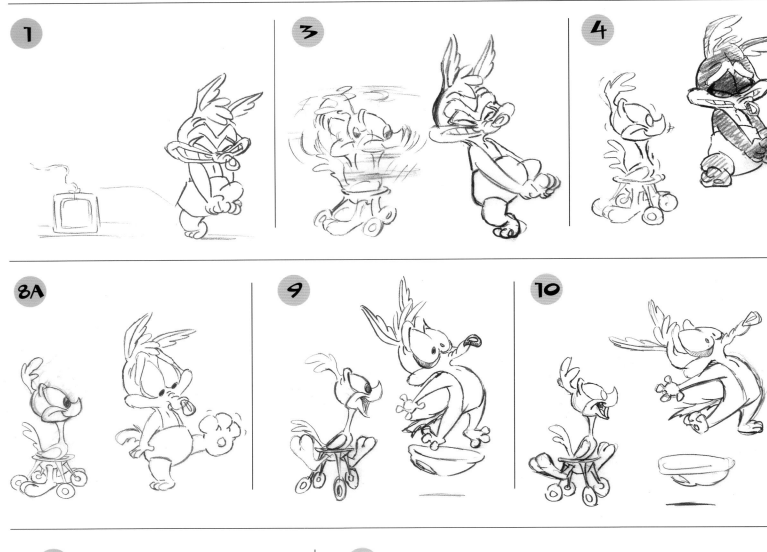

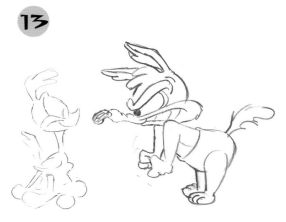

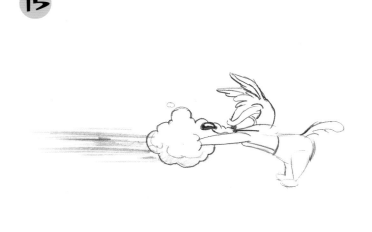

An animator needs several things to begin animating a scene, including a vocal track transcribed on exposure sheets, the background layout, and the character layout. The character layout may be a couple of simple drawings that illustrate the basic blocking of the scene, or it may be very elaborate. The character layouts below, from *Little Go Beep,* were drawn by the film's director, Spike Brandt. Spike has gone past the process of thumbnails and has created quite a few good drawings for the animator to start with.

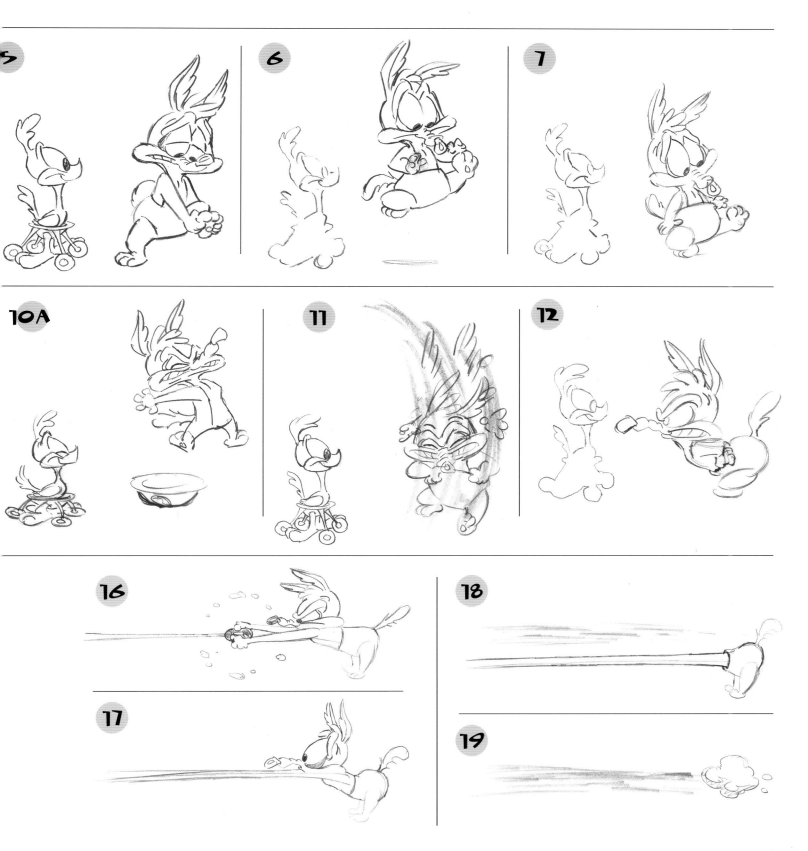

BASIC WALK CYCLE

Making a character walk is not as easy as it seems. When I was a young, wet-behind-my-ears animator, I had a terrible time with walking and running actions. My animation seemed stiff and odd. It was lacking a sense of effortlessness and grace. It takes a lot of practice to learn, but keep at it. Don't get discouraged!

Enough with the pep talk. Let's take a look at some cycles adapted from classic Looney Tunes cartoons. What's a "cycle" you ask? A *cycle* is a type of animation that is used again and again to prolong an action. The cycle starts with the first drawing, completes an action step by step through consecutive drawings, and "cycles" back into the first drawing. In this first set, Daffy has his right foot raised. Then he steps down with it and raises his left foot. He steps down with his left foot and begins to raise his right foot again. The first drawing is repeated to continue the action—a full cycle.

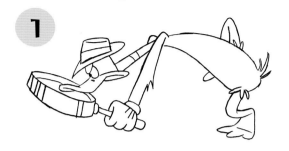

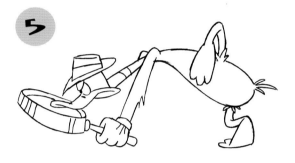

Check out Elmer's walking action. Man alive, he is one smug dude! Don't make the audience wonder what the characters are thinking. Draw it!

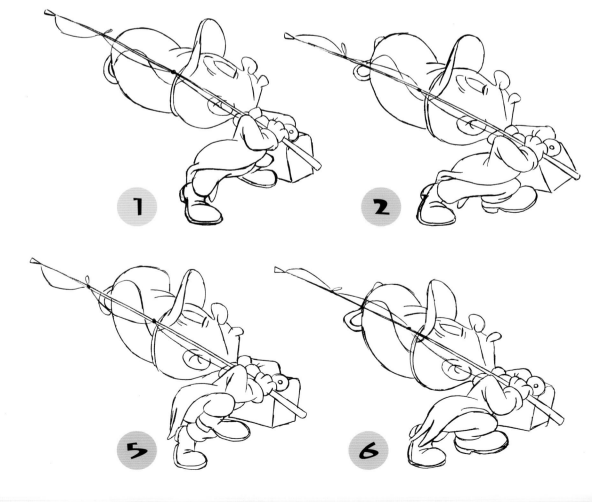

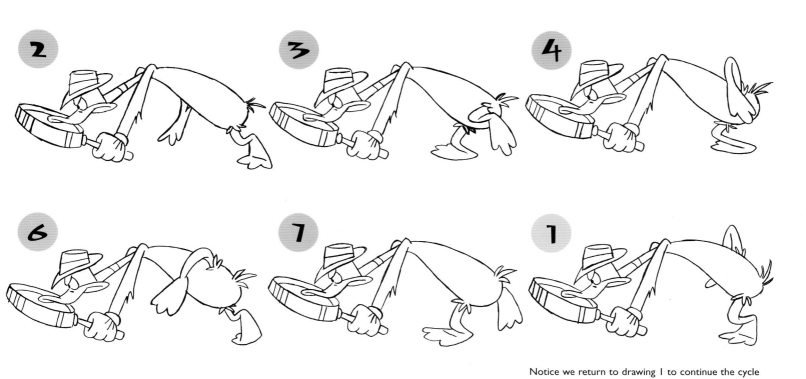

Notice we return to drawing I to continue the cycle

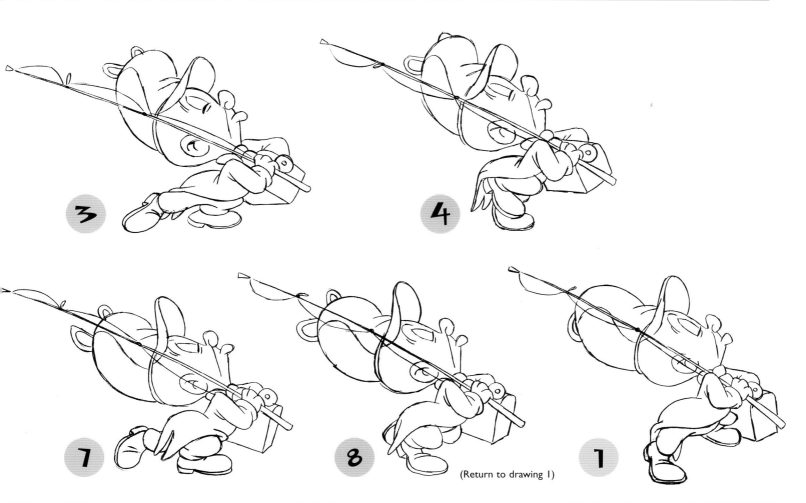

(Return to drawing I)

BASIC RUN CYCLE

Here's a funny run. Who would have ever thought that this portly little porker could move so fast? Look at his face. He might be a good-natured guy in general, but something must have gotten him all worked up!

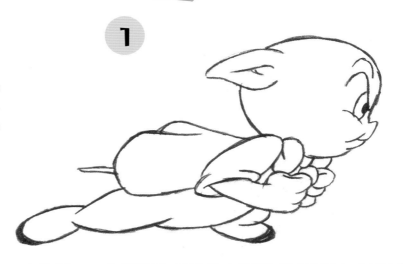

1

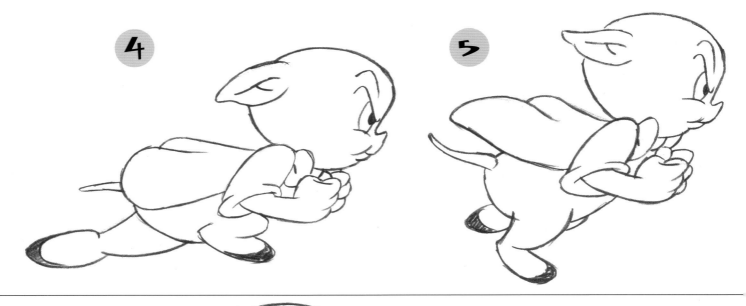

4

5

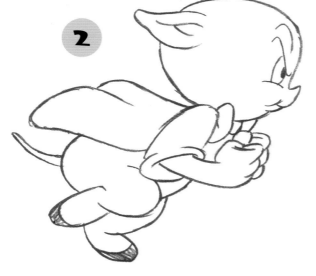

2

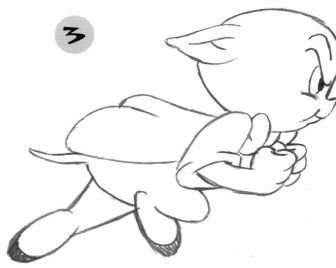

3

Now do you see why I said that this would take some practice? Study the action. Remember that every drawing should entertain the audience and clearly convey the character's emotions. Looney Tunes characters don't have "stock" walks or runs. Every movement they make is unique to their own moment in time, and every movement strengthens both the character and the story.

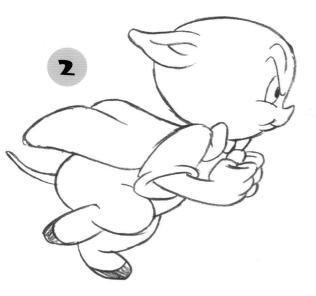

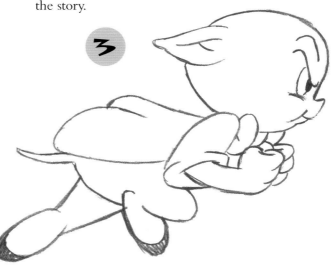

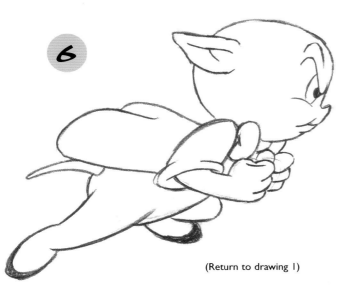

(Return to drawing 1)

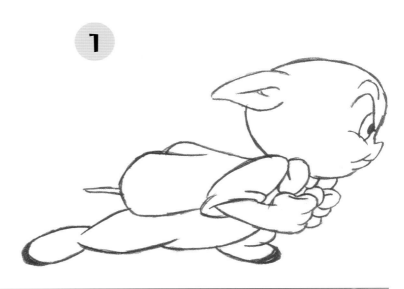

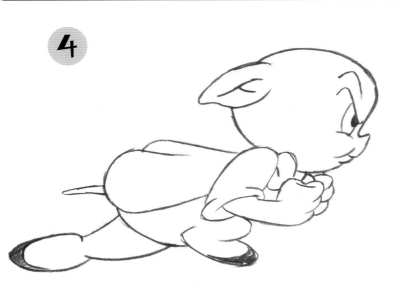

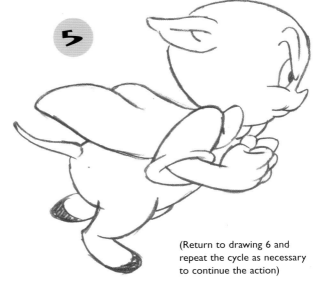

(Return to drawing 6 and repeat the cycle as necessary to continue the action)

OTHER ACTION CYCLES

Here are another couple of examples of animation cycles adapted from classic cartoons. Bugs is doing a high-speed "tip-toe" run, and Sylvester is moving in an odd "four-legged gallop." Take a look at the characters' faces, body language, and expressions. Bugs seems to be enjoying what he's doing, while Sylvester seems to be in a bit of panic. It seems that there is some storytelling afoot, folks.

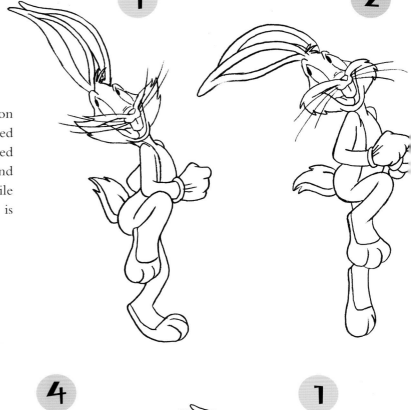

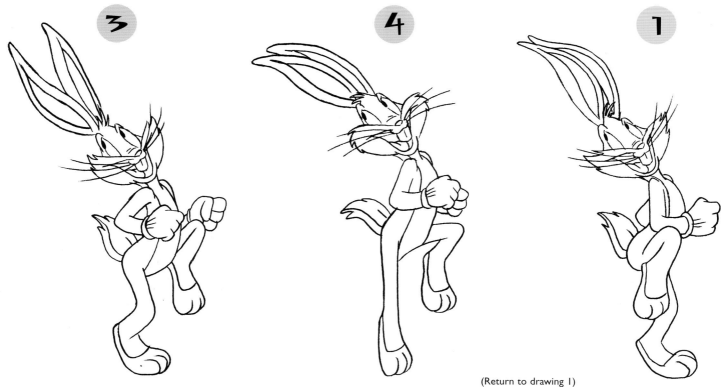

(Return to drawing 1)

Both of these actions are pretty fast. What would you do if you wanted the action to appear slower? Why, you would put in more "in-betweens." What are *in-betweens,* you ask? Well, gentle reader, just turn the page …

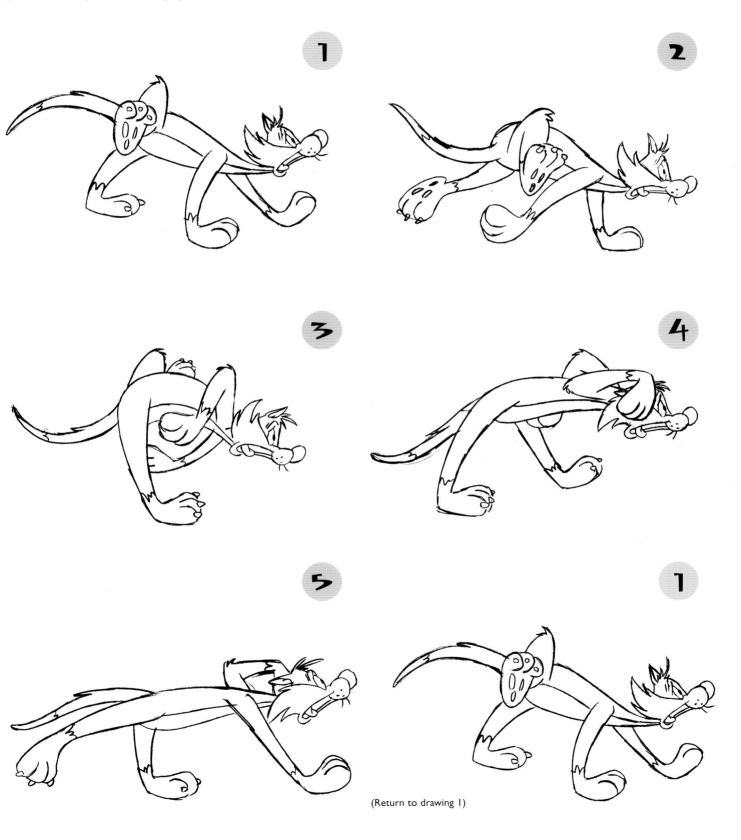

(Return to drawing 1)

KEYS AND in-BeTWEENS

Character animation, in its most basic form, boils down to a series of drawings called "keys" and "in-betweens." The drawings that cover the most important part of the action are the *keys*. The drawings that work from key to key are the *in-betweens,* so called because they fall in-between the keys. The more in-betweens, the longer it takes to get to the next key; the fewer in-betweens, the faster you go. Sounds simple, right? I'm afraid not. This simple description just scratches the tip of the animation iceberg; a good sense of timing takes years to develop. Sometimes you want very few or even no in-betweens to deliver a sharp, snappy action. Other times you might want many in-betweens to slowly cushion into a drawing that will hold on-screen for a long time. It is normal for your first few attempts at timing to come out either too fast or too slow. Don't get discouraged! Keep practicing!

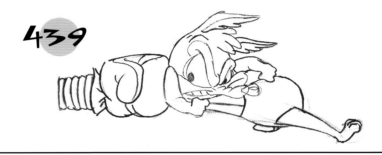

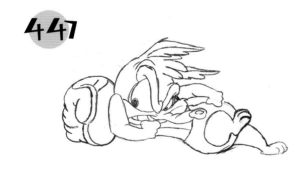

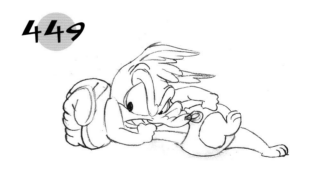

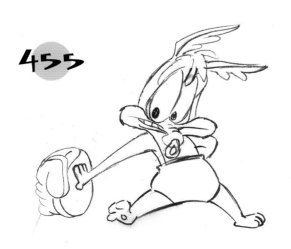

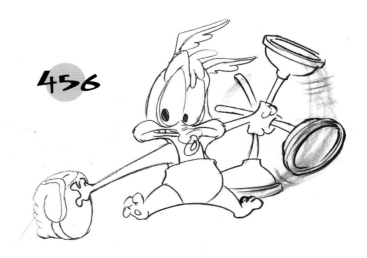

Take a look at these animation drawings from *Little Go Beep* drawn by Spike Brandt. First, keep in mind that each line on the exposure sheet indicates one frame, and there are 24 frames in 1 second of film. The numbers on each drawing indicate where they fell in the scene. For example, the drawing numbered 25 means it fell on the 25th frame of the scene. The missing numbers in the sequence represent the missing in-betweens. Pay attention to where the keys and in-betweens fell in this scene of animation. What if there were fewer in-betweens between the keys? What would that do to the timing of the animation?

Don't get intimidated by all these numbers. You may think math is icky, but if you do this long enough, and study hard, you can focus all your attention on more important things—like drawing silly cartoons!

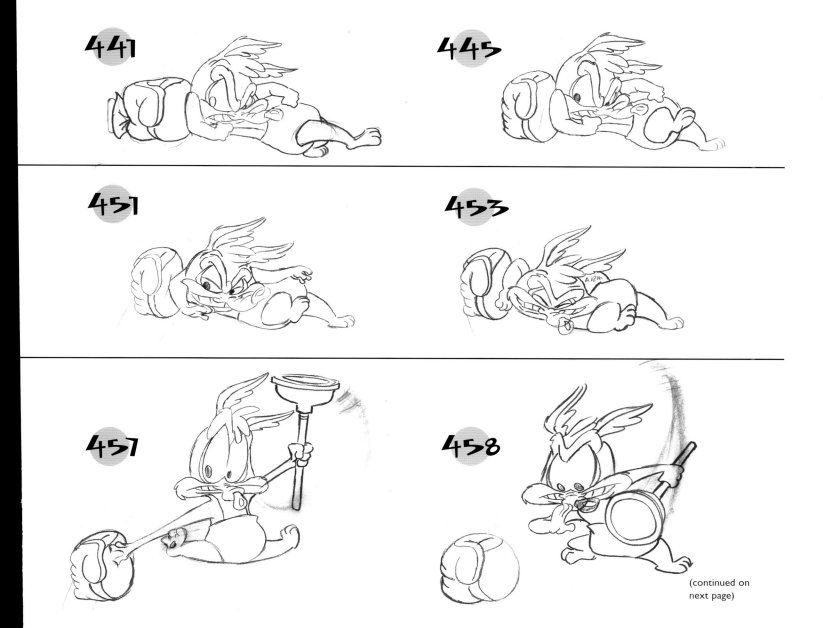

(continued on next page)

MORE KEYS AND IN-BETWEENS

459
460
461

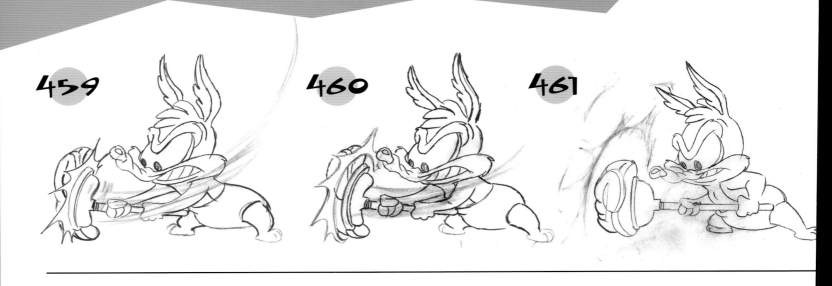

469
491
493

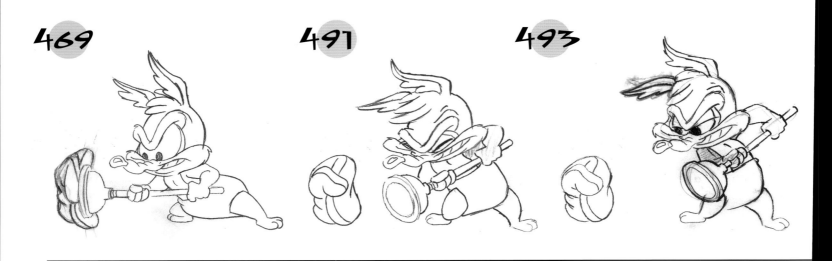

501

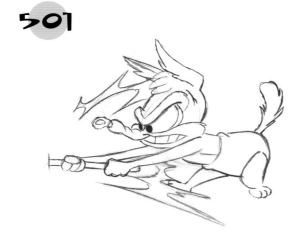

502

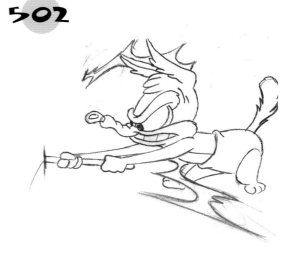

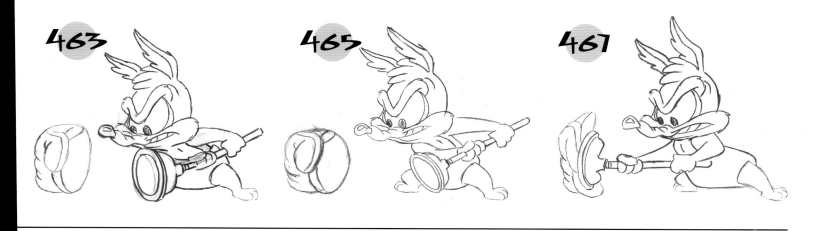

463 465 467

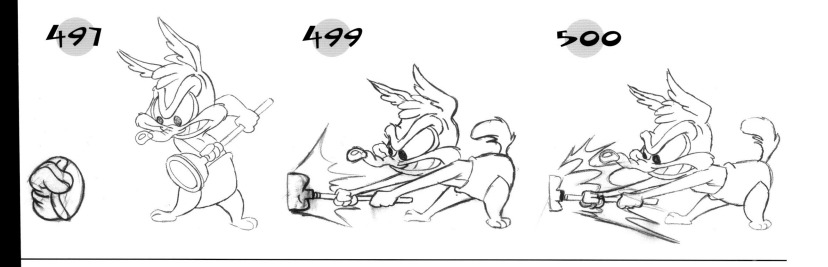

497 499 500

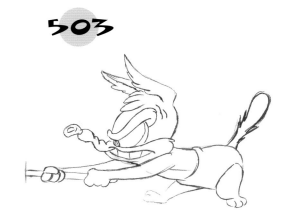

503

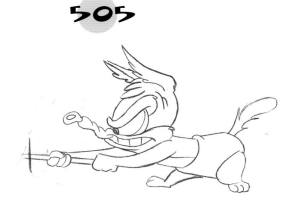

505

POSE-TO-POSE ANIMATION

Animation that calls for well-planned key poses to determine the action and expression of the character is called "pose-to-pose" animation. *Pose-to-pose* is a great technique for animation that requires strong staging, emotional acting, and subtle movement. This style of animation takes a step beyond thumbnails and character layouts and defines the character's action in much greater detail.

At this stage of the game, the animator must be fairly adept at drawing basic forms and head construction. The animator must also not forget the lessons learned about line of action and good design. It is also important to render broad, emotional expressions. Did you really think that I was kidding about starting simple and progressing from there?

Take a look at this scene from *Space Jam,* animated by Tom Riggin using pose-to-pose techniques. In this scene, Tweety uses his adorable persuasion to get basketball great Michael Jordan to come to his rescue. Tweety may look afraid and defenseless, but his quick smirk to the audience lets everyone know that this little yellow bird is well adept at subterfuge and blackmail.

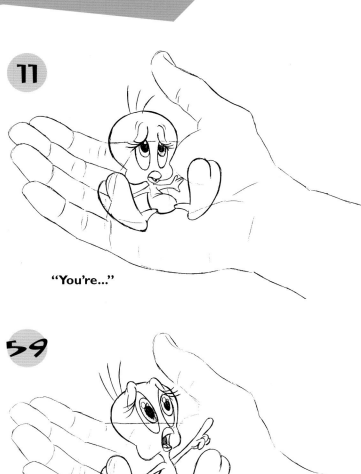

11

"You're..."

59

"..."

MORE TRICKS OF THE TRADE

For *Space Jam,* to help blend the traditionally animated Tweety body into the traditionally human Michael Jordan's hand, we needed to add many computer-assisted "tricks." To help match the lighting on the hand to the lighting on Tweety, we created special mattes, which appeared as shadows; we placed shadows on Tweety that matched the shadows on Michael's hand. We also placed shadows cast from Tweety onto Michael's hand.

The computer also helped match the movement of Tweety with the very subtle movements of the hand. Whew! It's not enough to worry about convincing and entertaining performances; the *Space Jam* animators were given enormous technical hurdles to overcome as well. I, for one, think that an excellent job was done by all.

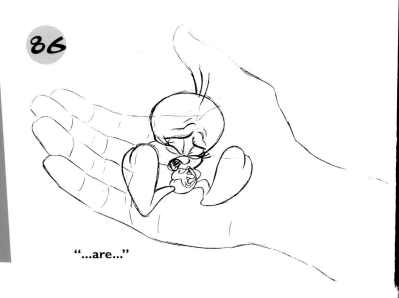

86

"...are..."

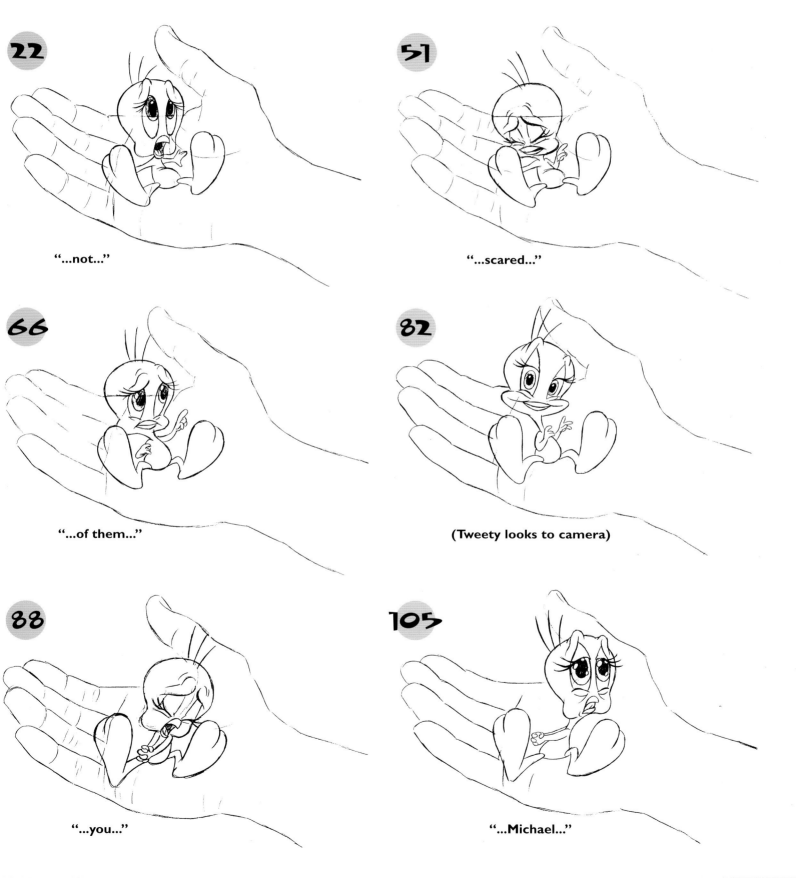

22 "...not..."

51 "...scared..."

66 "...of them..."

82 (Tweety looks to camera)

88 "...you..."

105 "...Michael..."

ANTICIPATION

To accent a strong move, an animated character needs to anticipate the action. The *anticipation* drawing is like the windup before the pitch or the crouch-down before the leap up or the pullback before the punch forward or . . . well, you get the idea.

In this scene from the Greg Ford/Terry Lennon–directed *Invasion of the Bunny Snatchers,* we find Bugs Bunny ready to retrieve an off-screen Porky Pig. Let's take a closer look at how the animator, Doug Compton, completed this action.

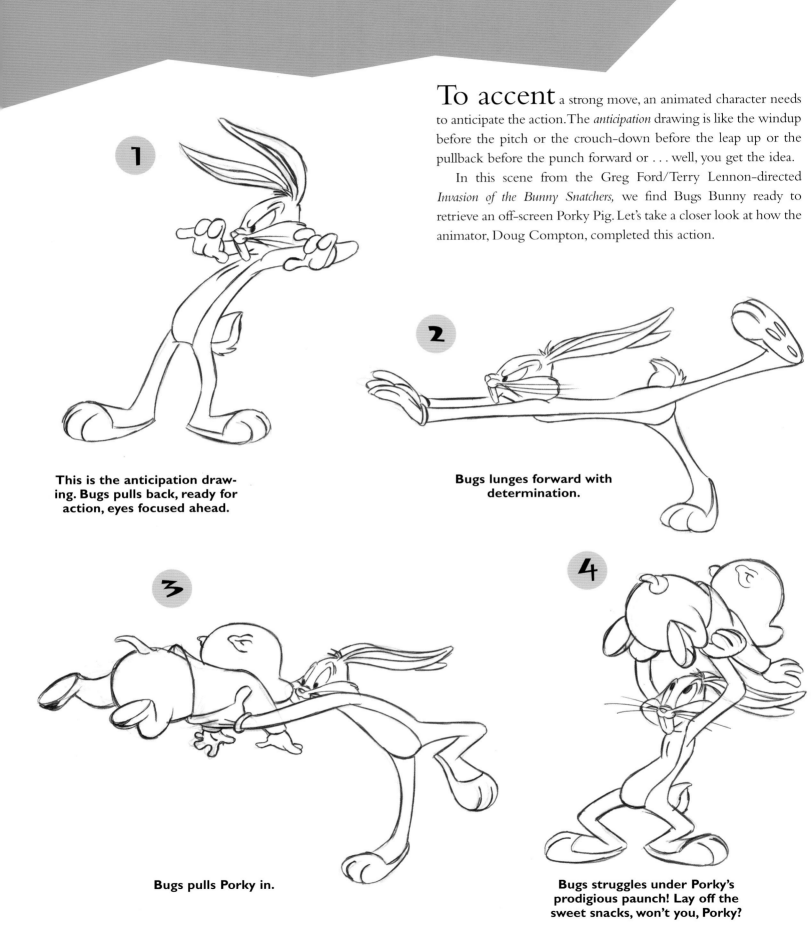

1

This is the anticipation drawing. Bugs pulls back, ready for action, eyes focused ahead.

2

Bugs lunges forward with determination.

3

Bugs pulls Porky in.

4

Bugs struggles under Porky's prodigious paunch! Lay off the sweet snacks, won't you, Porky?

THE "TAKE"

The *take* is an accent movement that is usually reserved for moments of extreme emotion. Takes are often the punchline to a joke, and they require precise timing and staging to work well. It's important to note that although takes work great as accents, if you use too many of them, they lose their impact and quickly become unfunny. So use them sparingly, kiddies!

Here are some examples of takes adapted from classic cartoons. Do you notice the strong lines of action and clean silhouettes? Check out the purity of emotion in those passionate expressions! Drawing funny rabbits and ducks is serious business!

Push the model when the track dictates. Aw, heck, push the model when the track doesn't dictate.

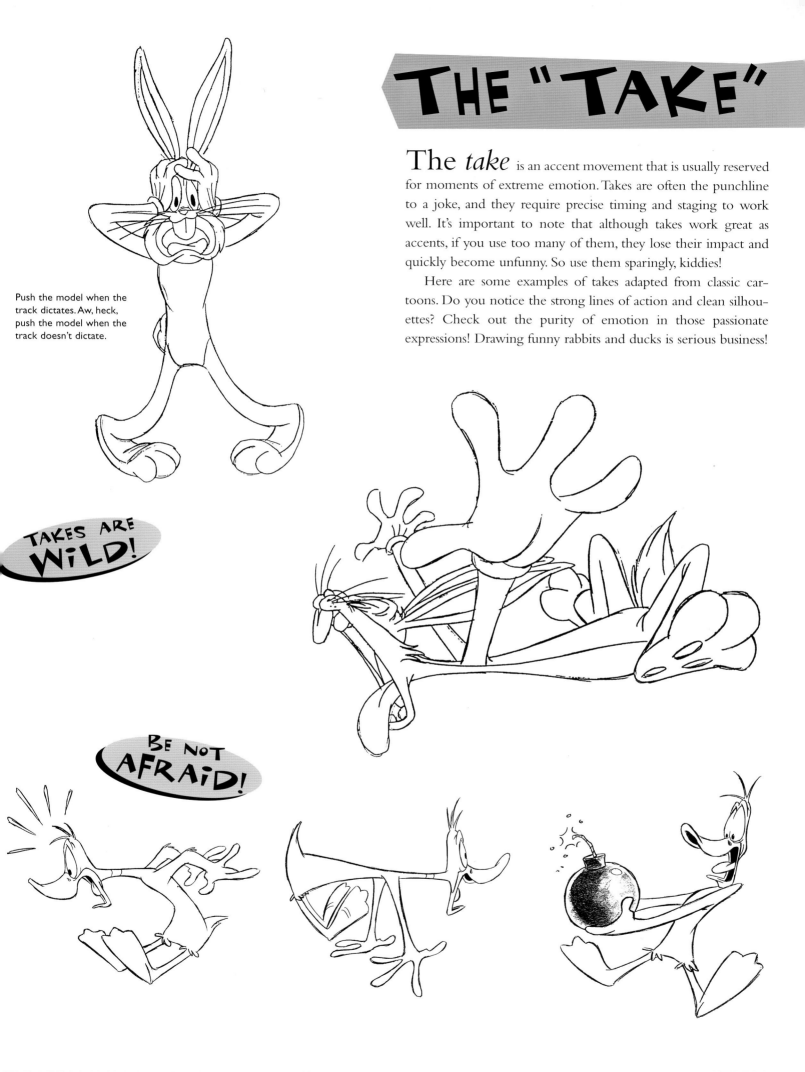

TAKES ARE WILD!

BE NOT AFRAID!

FAST ACTION

Sometimes, to accentuate a very fast action, the animator will use specialty drawings—*smears* and *multiple images*—to give the animation a special *zip* or *zing*. These drawings usually fly by so fast (1/24th of a second!) that the untrained eye can't even see them! However, they can be felt. That's right—when used correctly, smears and multiple image drawings can deliver a really sharp abrupt start or stop. But beware: Overuse of this technique can be as annoying as using too many takes. Too much spice spoils the soup!

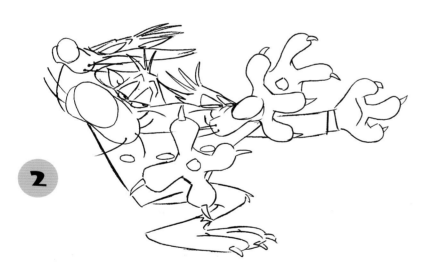

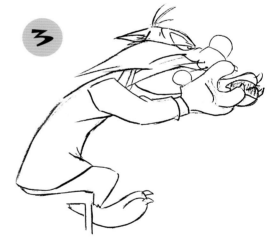

MULTIPLE IMAGES

Quick, darting movements aren't restricted to flailing arms and legs. In this scene from the Doug McCarthy-directed *Carrotblanca*, animator Spike Brandt has Sylvester moving so fast, it appears that he has three heads! This drawing helps accent Sylvester's quick whip-around and plays well against his smug expression.

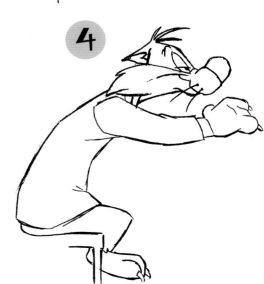

SMEARS

In this example, specifically drawn up by yours truly, a very intense and determined Bugs makes two very fast moves.

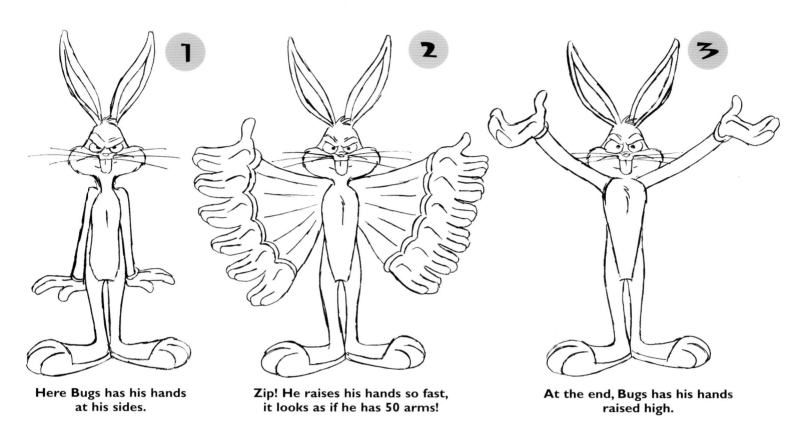

Here Bugs has his hands at his sides.

Zip! He raises his hands so fast, it looks as if he has 50 arms!

At the end, Bugs has his hands raised high.

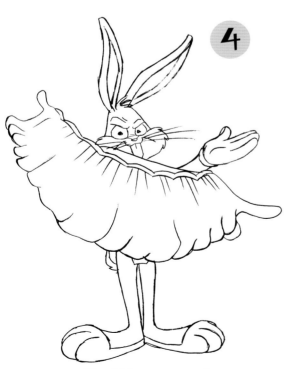

Zing! He moves so fast that his hand appears as one big smear.

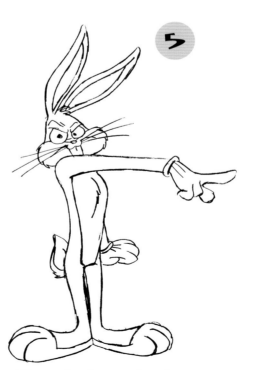

The action is completed.

STRONG PHYSICAL ACTION

Who says that only muscled, macho types are capable of strong physical actions? Why can't the small and defenseless or soft and feminine characters be capable of turning in an impressive athletic performance? Looney Tunes cartoons stand proud and celebrate the unexpected!

Let's take a look at two examples from *Space Jam*. First, check out Tweety. Wow! Master animator Jeff Siergey shows us that powerful, explosive energy can come in even the smallest and cutest packages!

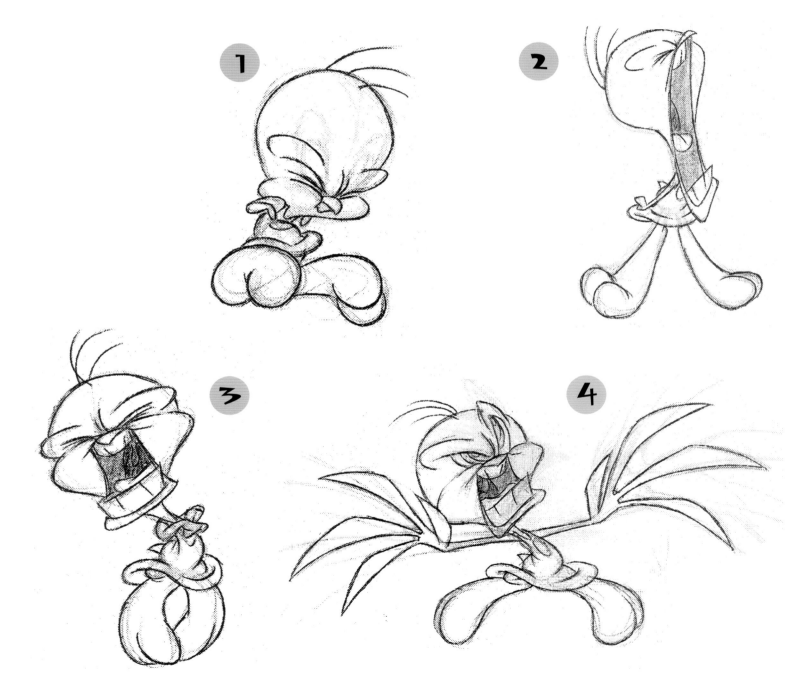

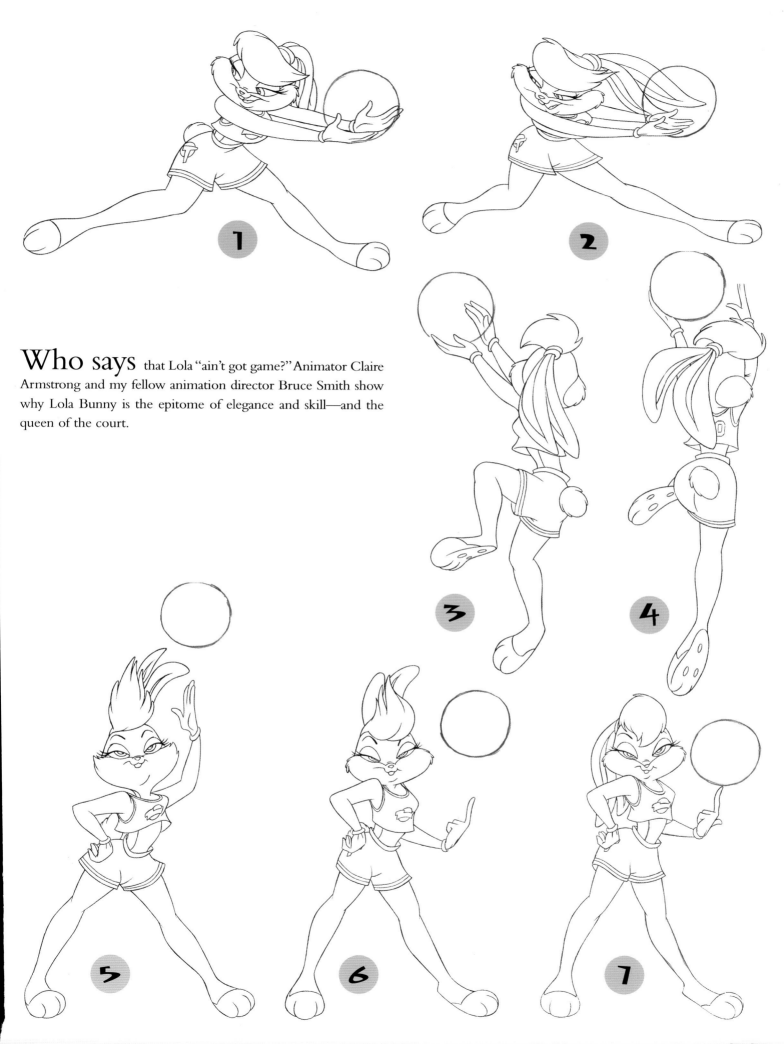

Who says that Lola "ain't got game?" Animator Claire Armstrong and my fellow animation director Bruce Smith show why Lola Bunny is the epitome of elegance and skill—and the queen of the court.

SQUASH AND STRETCH

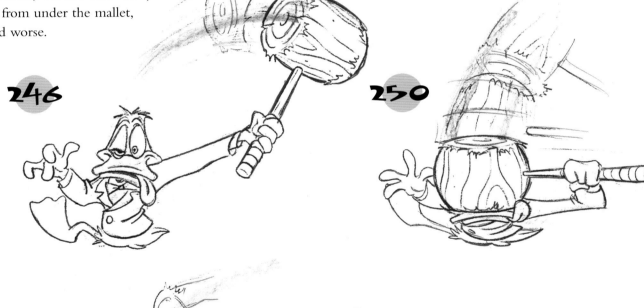

242

Squash **and** *stretch* are the animation equivalents of the laws of force and reaction in physics. When a large, solid object (say, a hammer) collides with a stationary object (like a head), the stationary object will react in a strong and violent manner (SQUASH!).

This animation technique is used to create a sense of weight, strengthen an impact, and accentuate a reaction. It has been a cartoon standby since the beginning, and it is critical in establishing a character's physical believability.

In this scene from *Carrotblanca*, animator Bill Waldman clearly illustrates the cause and effect of a rather large mallet squashing and stretching poor Daffy Duck's head. (Don't try this at home!) Notice how every time he comes out from under the mallet, he looks worse. And worse.

246

250

257

258

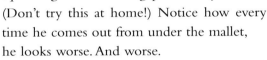

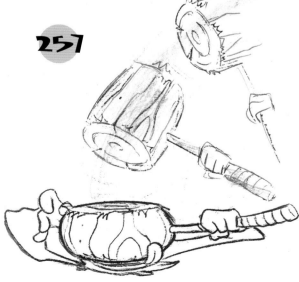

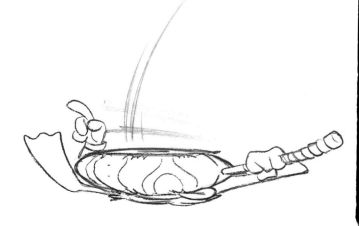

78

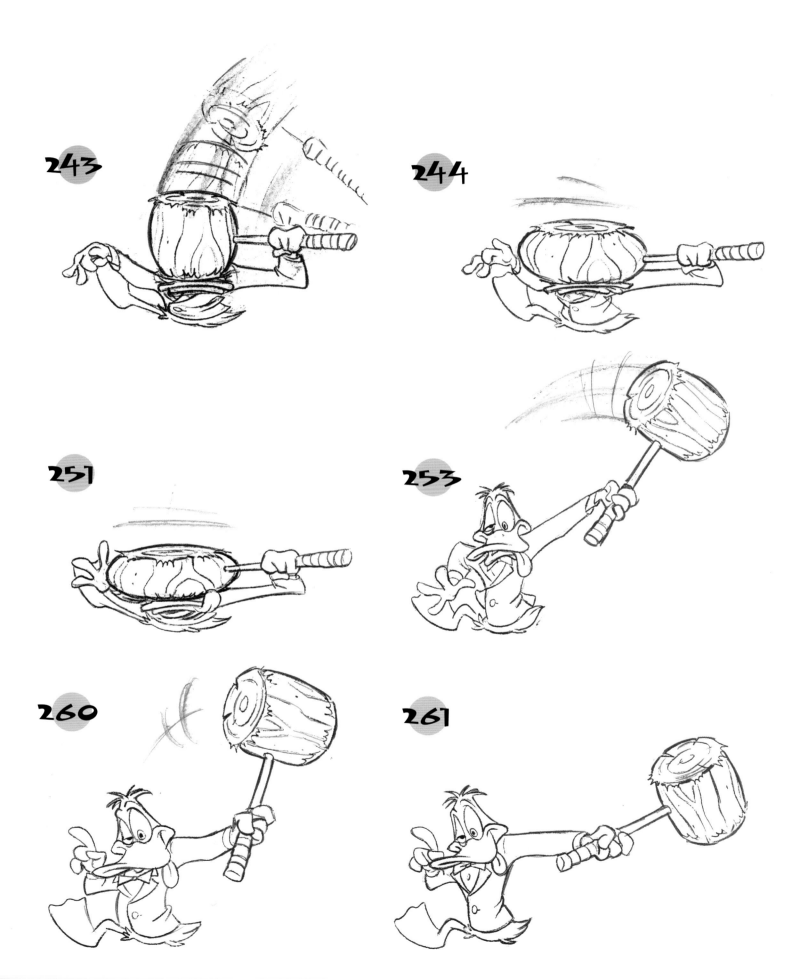

243

244

251

253

260

261

MORE SQUASH AND STRETCH

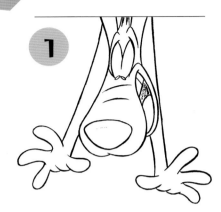

Squash and stretch is so important that we may as well include another example, this time from a TV spot directed by Darrel Van Citters. Can you see how animator Jason Lethcoe accentuates Barnyard Dog's stretch as he plummets toward the pavement and squashes with tremendous force on impact? You can really feel the weight and volume! Squash and stretch is good, clean, animation fun!

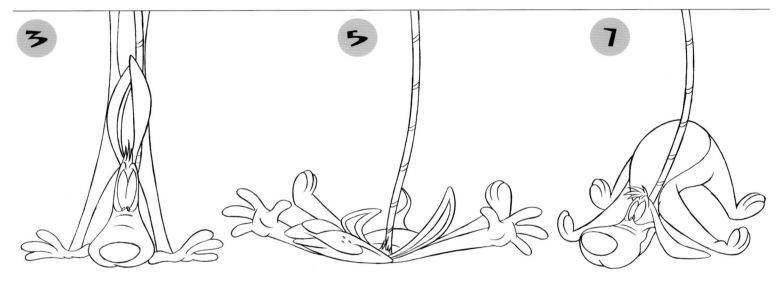

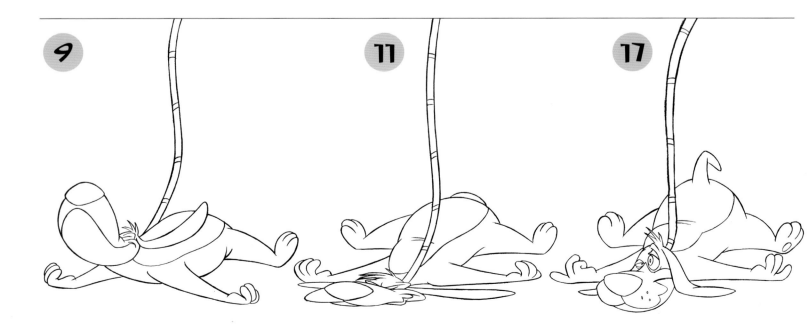

23 Sometimes the use of squash and stretch manifests itself in more delicate ways than in hammer hits and stage dives. Take a look at this scene from *Carrotblanca,* animated with great skill by Sean Keller. Pay attention to Penelope's subtle stretches as she futilely attempts to free herself from Pepe Le Pew's amorous advances. I know I sound like a scratched CD, but notice the staging and silhouetting of Sean's drawings. Study the contrast between Pepe's romantic gaze and Penelope's expression of pure panic. This is what the Looney Tunes style of animation is all about!

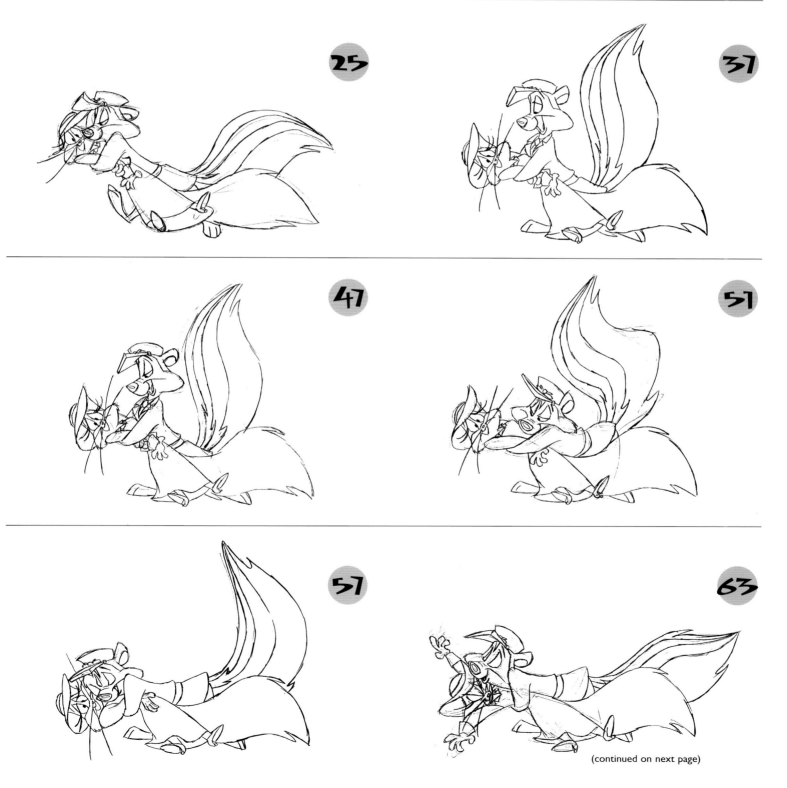

(continued on next page)

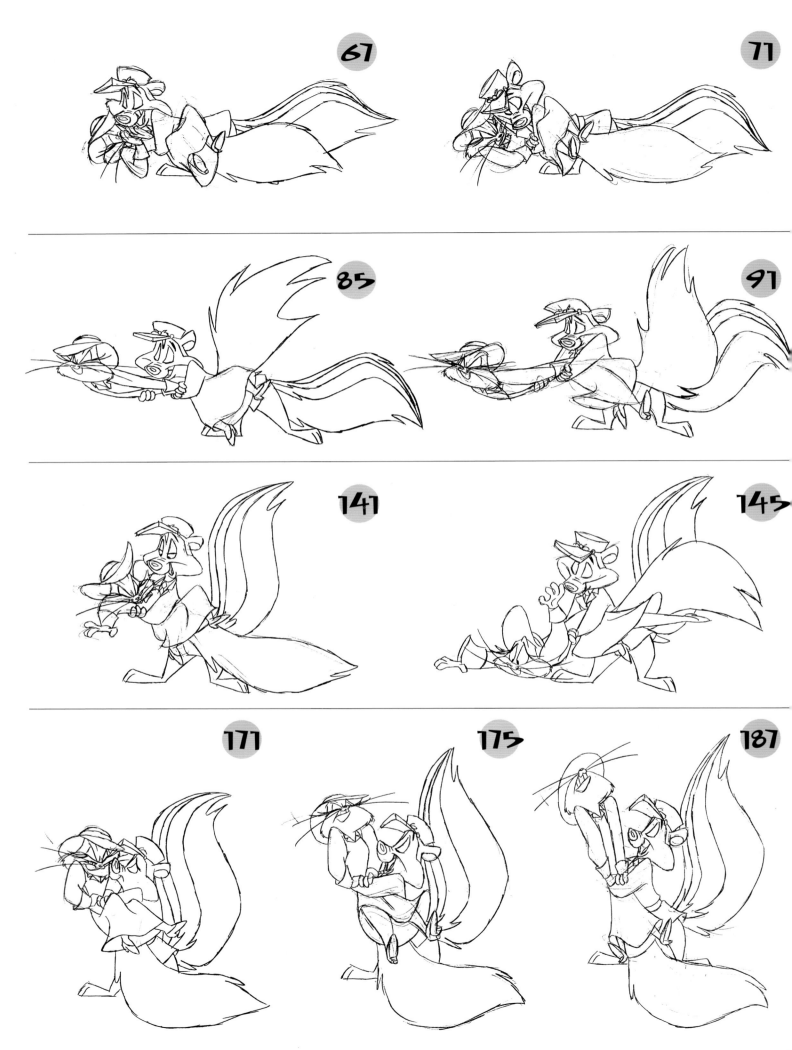

67

71

85

91

141

145

171

175

187

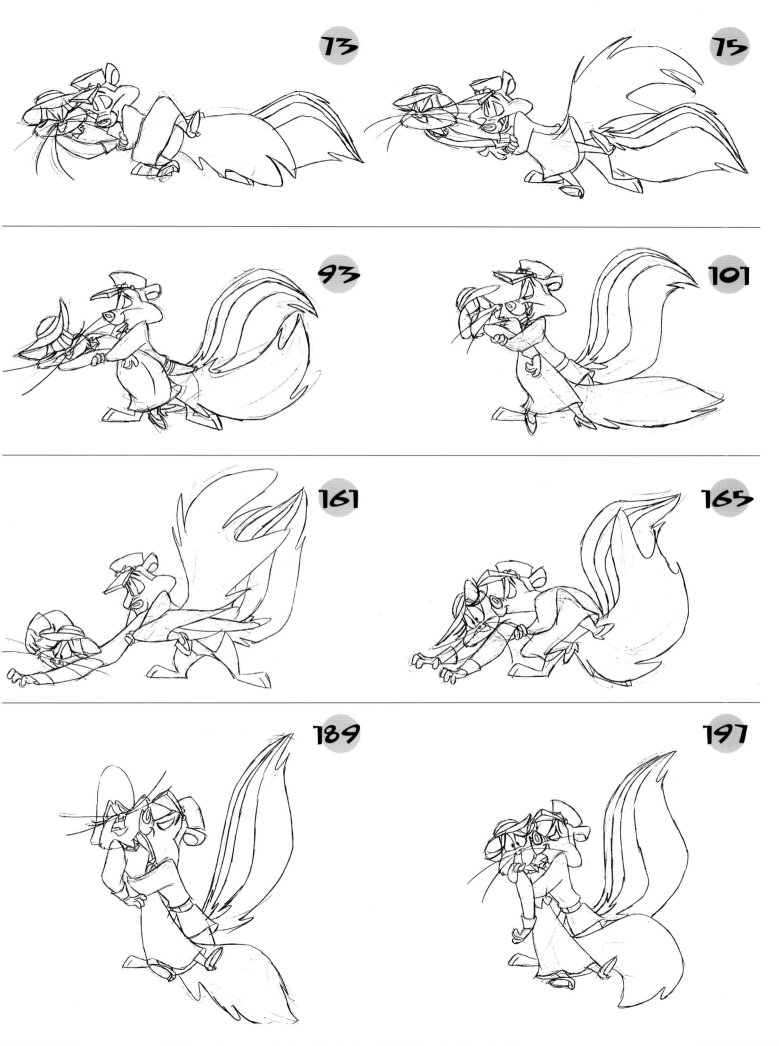

STRAIGHT-AHEAD ANIMATION

Pose-to-pose style animation isn't always the best approach. Sometimes, especially when creating a sequence of growth or movement, animators need to use the *straight-ahead* approach. That is, rather than focusing on the key poses and filling in the in-betweens, the animator starts at Drawing 1 and continues straight on, to the last drawing. This time the animator isn't so concerned with the final pose that the character will eventually settle into; instead, the animator is totally focused on the progress of the action—and sometimes the journey is even funnier than the destination! It's exciting to animate this way, and many times the animator is as surprised with the final result as the audience is!

Take a look at the example shown here. Here comes Wile E. Coyote with an extra bit of added energy, courtesy of straight-ahead animation. To get the bounce and reaction just right, Ashley Brannon started at the beginning of the action and animated Wile E.'s run toward the camera from there. He even gets bigger and bigger as he approaches the foreground. Do you think that the hammer and wooden boards are part of another Acme-brand, easily assembled, sure-fire disaster in his quest to capture the fast-moving Road Runner? Maybe Wile E. should switch manufacturers.

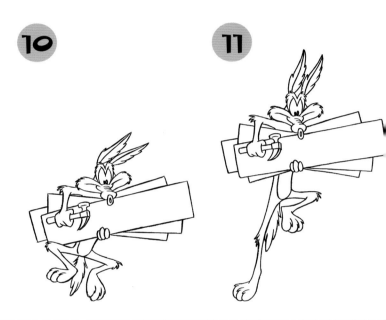

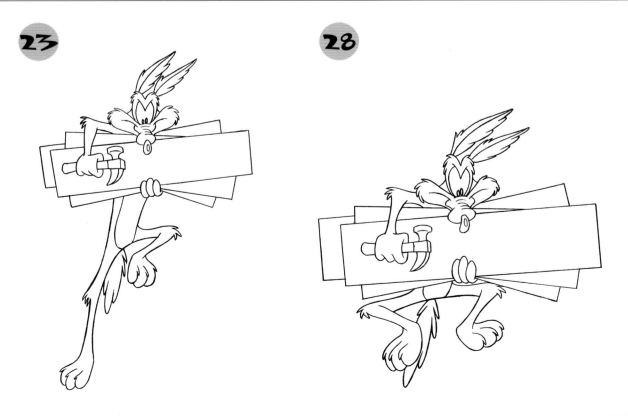

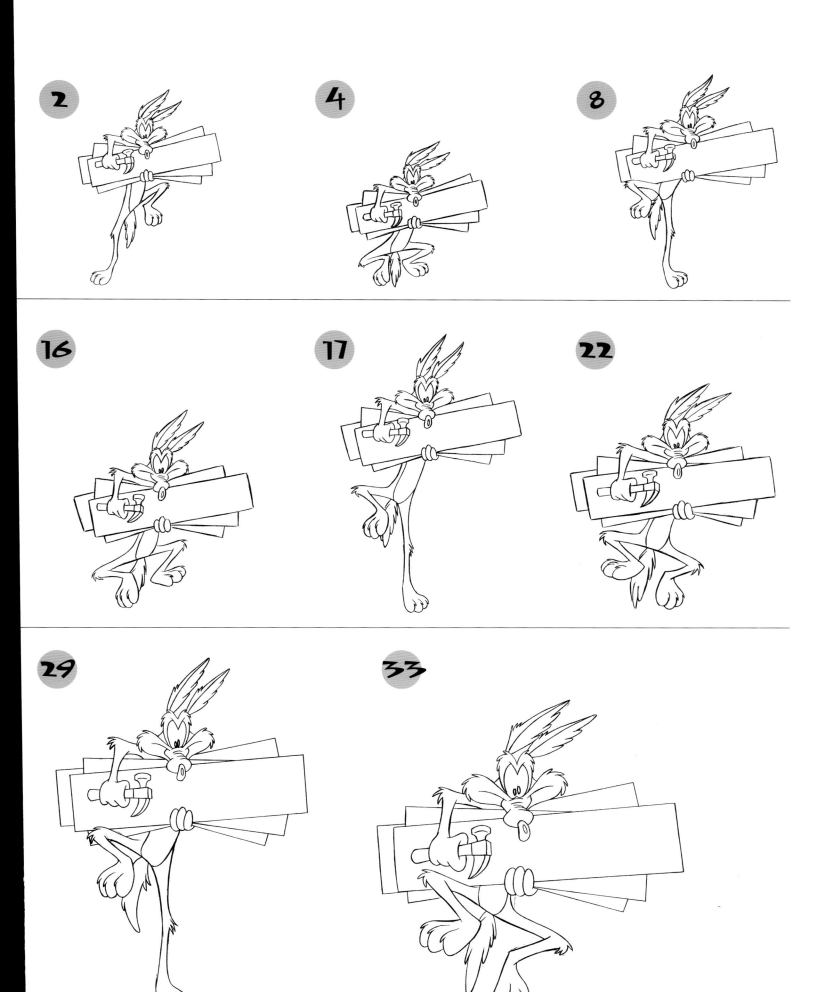

MORE STRAiGHT-AHEAD AniMATiON

Animator Bill Waldman decided that straight-ahead animation was the best approach for Yosemite Sam's wild action in this scene from *Carrotblanca*. Judging from the wild and frantic result, I guess Bill was right.

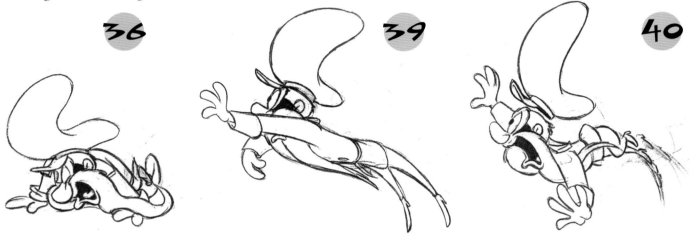

This scene from a TV commercial directed by Jeff Siergey uses straight-ahead animation to give Taz an even greater sense of fury. T. J. House's animation has a convincing sense of weight and physical realism, and he has captured the pure, animal menace that has made Taz a favorite of fans everywhere.

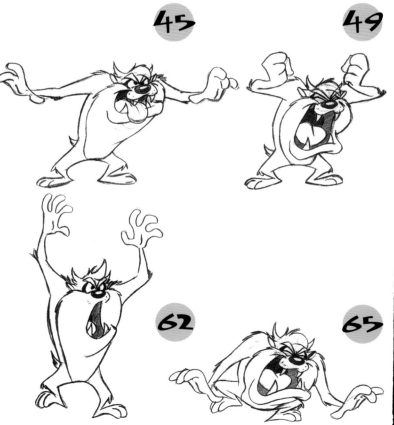

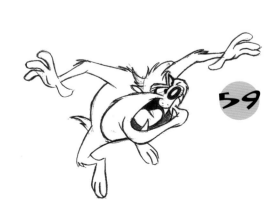

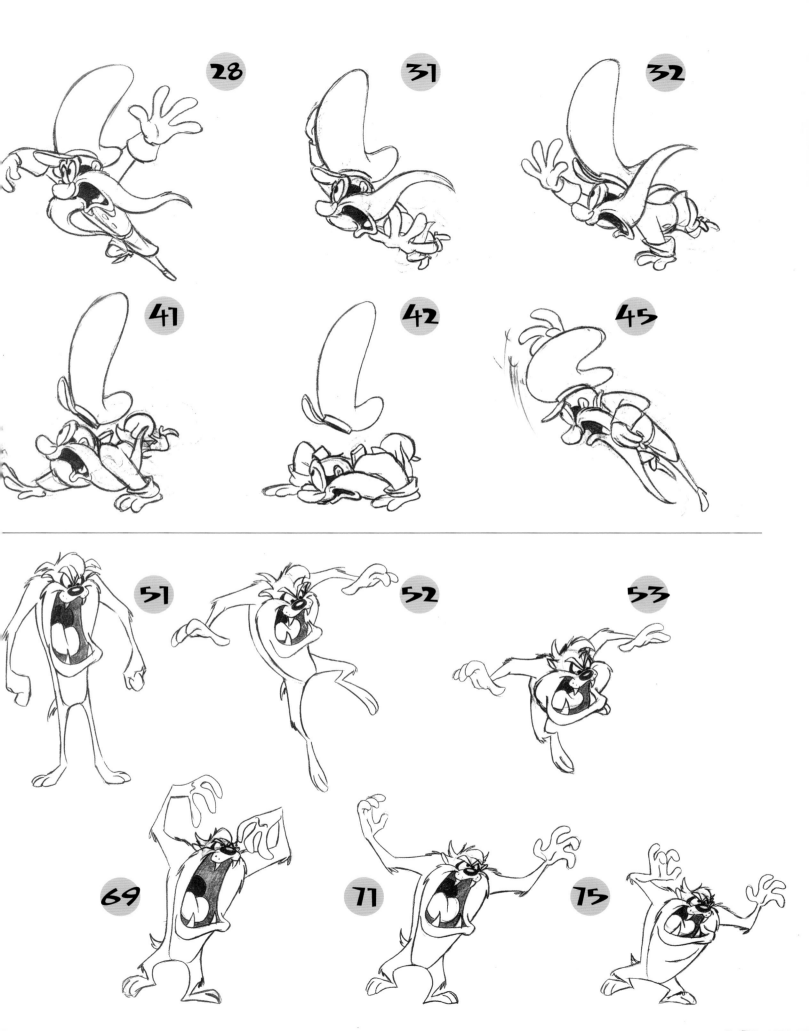

ACTiNG

Well, it certainly was a long road that led us here. We studied design and form and different animation techniques. Now we get to the heart of the matter. This is the stuff that magically transforms mere pencil drawings into creations that move us and make us laugh. This is *acting*. It's been said before that animators are nothing more than "actors with pencils," but here is the biggest secret of all: When you animate Bugs Bunny, you *are* Bugs Bunny. When the right expression melds with the correct timing and when the exact bit of squash and stretch blends with the perfect script and line reading, something magical happens, and Bugs Bunny is there.

The Looney Tunes are not simple, one-dimensional characters, even though they are nothing more than a collection of lines on paper. The contribution of the many writers and artists involved in the creation of even a single Looney Tunes cartoon fuels the characters with an energetic versatility. Bugs is no "one-trick bunny," folks. There is a reason that he has remained one of Hollywood's greatest actors all these years.

In this scene from the film *Box Office Bunny* animated by Toby Shelton, we find Bugs addressing us, the audience, as if he were our pal. This is a common scenario for the last scene of a Bugs Bunny cartoon. This is where he says the last funny line, we "iris out," and the "That's all, folks!" title writes itself across the screen. Bugs is wide-eyed and joyful, and the audience can take him at his word. This is a shared experience between friends.

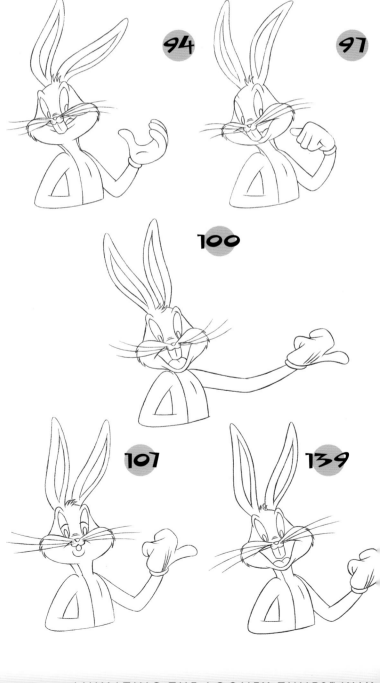

60 92 94 97 100 103 105 107 139

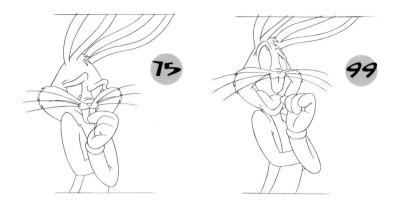

In this next scene from *Space Jam,* animator Brian Smith clearly shows us a different side of our favorite rabbit. In comparison to the scene from *Box Office Bunny*, Bugs' furrowed brow and shifty eye movement clearly communicate that he is deeply entrenched in his latest trick or scam. Why, it's no surprise to learn that in this scene, Bugs is quickly outsmarting his interstellar foes, the Nerdlucks. A simple glance tells the audience that Bugs is getting himself out of trouble and turning his enemies into mental mincemeat.

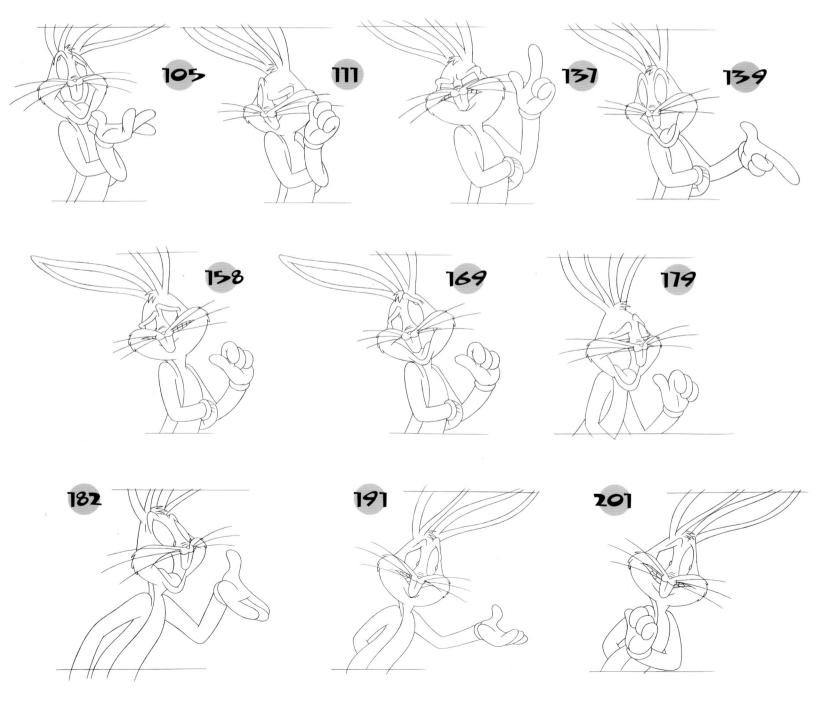

MORE ACTING

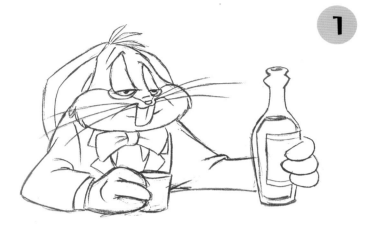

1

We have seen a genuine and friendly Bugs. We have seen a cunning and devious Bugs. Now, in the name of emotional versatility, we have a Bugs we rarely get to see—a down-on-his-luck Bugs. In a scene from *Carrotblanca,* animator Jeff Siergey brings us a distressed Bugs Bunny languishing over his lost love and drowning his sorrows in a bottle of carrot juice. Who knew that seeing the rabbit in such a condition would tug on the heart strings so.

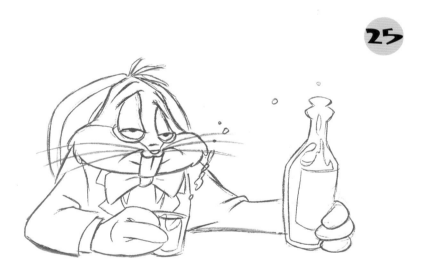

25

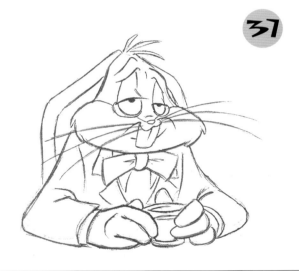

37

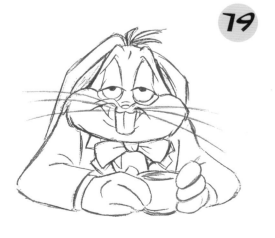

79

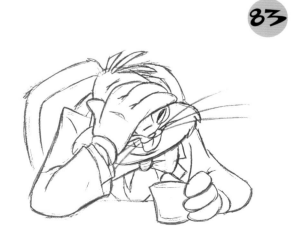

83

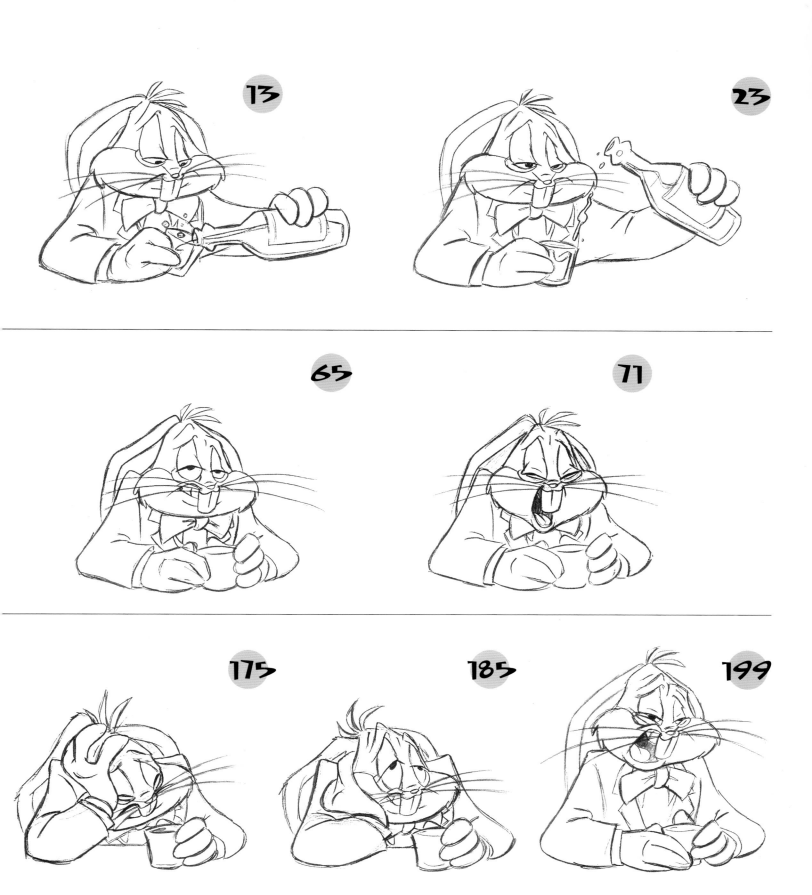

PUTTING IT ALL TOGETHER

We took the time to touch upon many things in this book. Now let's take a look at some final images, or *frames*, from several different Looney Tunes projects. As you can see, the same rules of good animation apply no matter where the characters are called on to perform. Whether they're on a painted background, a live action set, or a completely digital environment, Bugs, Daffy, and the rest of the crew stay true to form!

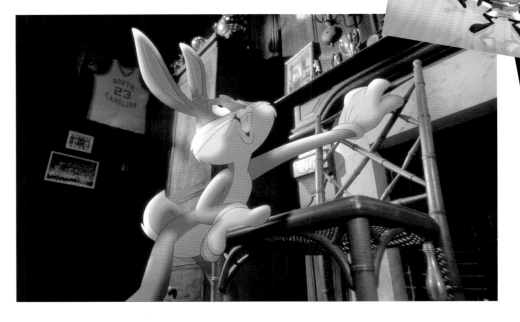

In these frames from *Space Jam*, we can see that Bugs, Taz, and Marvin aren't in a cartoon setting at all. The chair that Bugs is holding is real. It was pulled across the set with wires, and the animation was added later. Both Taz and Marvin are placed in a sports arena that was completely created in the computer. In fact, even the basketball that Marvin is holding is computer generated!

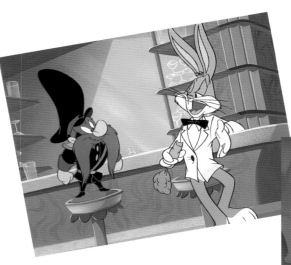

In the animated short *Carrotblanca,* the Looney Tunes performed in a lush, highly rendered setting that was meant to evoke the feeling of the classic Hollywood film *Casablanca.* Notice the shadows on the walls and the attention to detail.

92

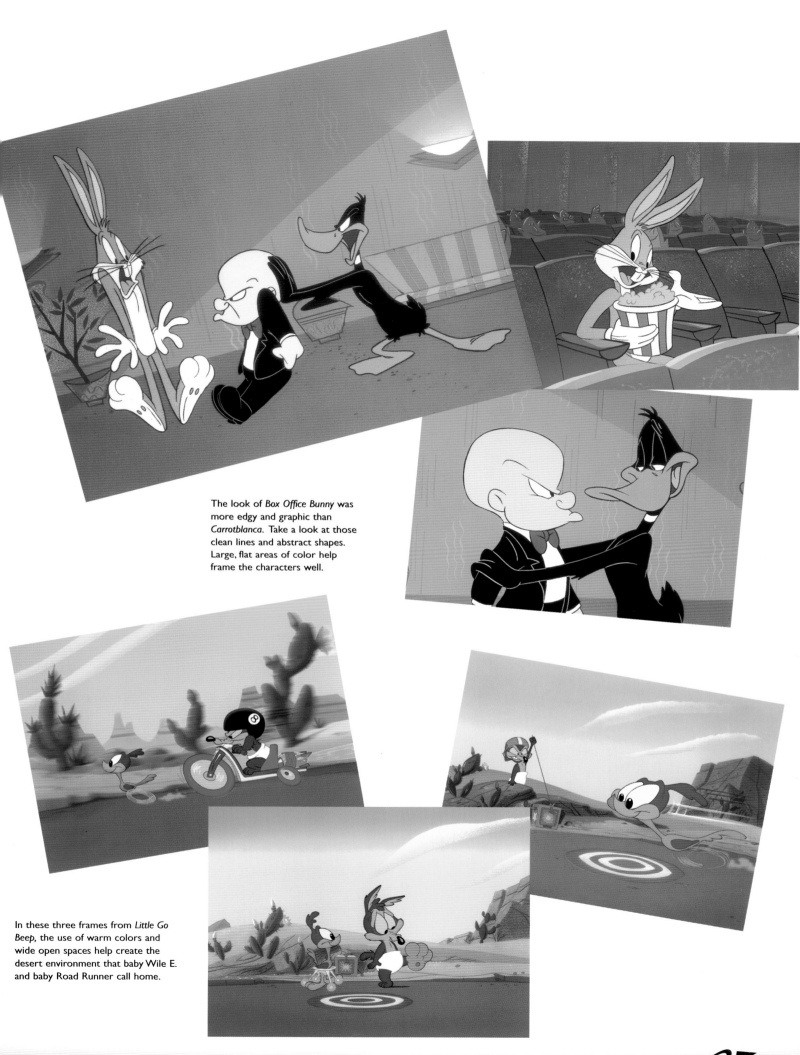

The look of *Box Office Bunny* was more edgy and graphic than *Carrotblanca*. Take a look at those clean lines and abstract shapes. Large, flat areas of color help frame the characters well.

In these three frames from *Little Go Beep*, the use of warm colors and wide open spaces help create the desert environment that baby Wile E. and baby Road Runner call home.

EPILOGUE

All right then, young cartoonists, you made it through Looney Tunes boot camp. As you go out into the world, just remember to stay loose! Don't panic if your drawings don't turn out the right way the first time you lay a pencil to paper. Study the pictures in this book. They were drawn by a vast collection of artists and reflect a variety of styles and influences, yet they all remain true to the characters they depict. If you draw the Looney Tunes from your heart, you can't go wrong. I won't be corny and say "that's all, folks," so in conclusion . . .

I hope you liked the book and that you learned something about Looney Tunes cartoons.

I hope that the next time you watch a cartoon, you will think more closely about what made you laugh and what didn't.

I hope you remember the work of the many talented people that make up the rabbit or the duck.

Most of all, I hope that, years from now, some of you will be making new Looney Tunes cartoons and that yours will be the best cartoons that anyone has ever seen.

SUGGESTED READINGS

One more thing: Every young cartoonist should study these books, so get them!

Cartoon Animation by Preston Blair (Walter Foster Publishing). An excellent, thoughtful source of information for animators of all ages.

Disney Animation: The Illusion of Life by Frank Thomas and Ollie Johnston (Abbeville Press). The greatest book on Disney-style animation by two of Disney's greatest animators.

The Looney Tunes and Merrie Melodies: A Complete Illustrated Guide to Warner Bros. Cartoons by Jerry Beck and Will Friedwald (Henry Holt Publishing). A useful research tool with more than 900 cartoons listed by year of release. Each entry includes information on directors, writers, animators, etc.

That's All Folks! The Art of Warner Bros. Animation by Steve Schneider (Henry Holt Publishing). A collection of classic Warner Bros. art and keen insights into what made the cartoons legendary.

ACKNOWLEDGEMENTS

To Lorri Bond and Kathleen Helppie-Shipley at Warner Bros. Classic Animation, who generously let me dig through their archives to find many of the images in this book and who continue to do everything they can to keep these characters at a TV, movie, or internet screen near you.

To Charles Carney, Allen Helbig, and Victoria Selover at Warner Bros. Worldwide Publishing, for helping me find frames and organize everything, and for general editorial "wonderfulness."

To Sydney Sprague, Barbara Kimmel, Shirley Kawabuchi, and the team at Walter Foster Publishing, for their patience during a long project.

To the many Warner Bros. writers, directors, animators, layout artists, background painters, inkers, painters, musicians, and sound artists, on whose rich legacy I am still able to draw a weekly paycheck.

To Greg Ford, who started this project with me and whose eloquence I tried not to destroy.

To Bob Camp, who supplied me with good notes and ideas.

To Jeff Siergey and Spike Brandt, who both helped me draw many of the pictures in this book and on whose support and guidance I rely on a daily basis.

To my parents, for figuring out that watching cartoons really was doing my homework.

To my lovely wife, Thea, who puts up with a lot of nonsense being married to a cartoon boy.

Tony Cervone

DIRECTOR,
WARNER BROS. ANIMATION